CAPTURING
FASHION
DERUJINSKY

CAPTURING FASHION

DERUJ

Flammarion

INSKY

Foreword by **EILEEN FORD** Text by **ANDREA DERUJINSKY**

EXECUTIVE DIRECTOR
Suzanne Tise-Isoré
Style & Design Collection

EDITORIAL COORDINATION
Inès Ferrand-Pérez

GRAPHIC DESIGN
Bernard Lagacé

COPY-EDITING
Barbara Mellor

PROOFREADING
Helen Downey

PRODUCTION
Angélique Florentin

COLOR SEPARATION
Les Artisans du Regard

NEGATIVE AND PRINT RETOUCHING
Mark A. Vieira/The Starlight Studio

PHOTO RESEARCH AND RESTORATION
Jessica Hastings/myvintagevogue.com

PRINTED BY
Geers, Belgium

Simultaneously published in French as
Glamourissime : Derujinsky, l'œil de la mode
© Flammarion S.A., Paris, 2016.

English-language edition
© Flammarion S.A., Paris, 2016

Flammarion S.A.
87, quai Panhard-et-Levassor
75647 Paris cedex 13
editions.flammarion.com
styleetdesign-flammarion.com

Legal deposit: 10/2016
ISBN: 978-2-08-020273-4

ENDSHEETS FRONT AND BACK, FROM LEFT
TO RIGHT AND TOP TO BOTTOM
Gleb with his mother Alexandra Micheloff-Derujinsky,
his older sister Natasha, and his father Gleb W. Derujinsky.
His love of horses and other animals was to play
a big part in Gleb's life; Gleb aged four; Gleb and his mother;
in 1936-37, Gleb's father taught at the Stickney School
of Fine Arts in Pasadena, where this photo in an orange
grove was probably taken; Gleb signed up for the US Army at
seventeen and two years later was staff sergeant. He spoke
four languages and claimed to have learned Morse code in
thirty days; self portrait, about 1946; self portrait, about 1946;
self portrait in natural light, about 1946; Gleb perched on a
roof in Thailand, photographed by his beloved right-hand
man Minoru Ooka; Gleb in the house in Pound Ridge that
he built and used as a natural studio; Gleb with his horse,
photographed by Ruth Neumann-Derujinsky; Gleb in Durango,
Colorado, photographed by Anthony Petrillose's wife, when
they visited Gleb and Wally to discuss a potential book project.
Gleb sits in a famous Pierre Paulin-designed Ribbon Chair.
© Kristen Roeder Petrillose; Gleb showing some of his prints
at the Open Shutter Gallery in Durango, which put on a show
of his work in 2004; Polaroid of Gleb at a dinner party.
PAGE 3 Planes, cars, and beautiful women: three of Gleb's
favorite things. The sleek scarlet lines of the "Revolutionary
new 1960 Valiant from Chrysler" (one of the first cars to
be designed with the help of computers) make a dashing
complement to a Luis Estévez sleeveless cotton dress
and black-and-white plaid jacket, with a dramatic hat by
Emme, and Christian Dior shoes, June 1960.

CONTENTS

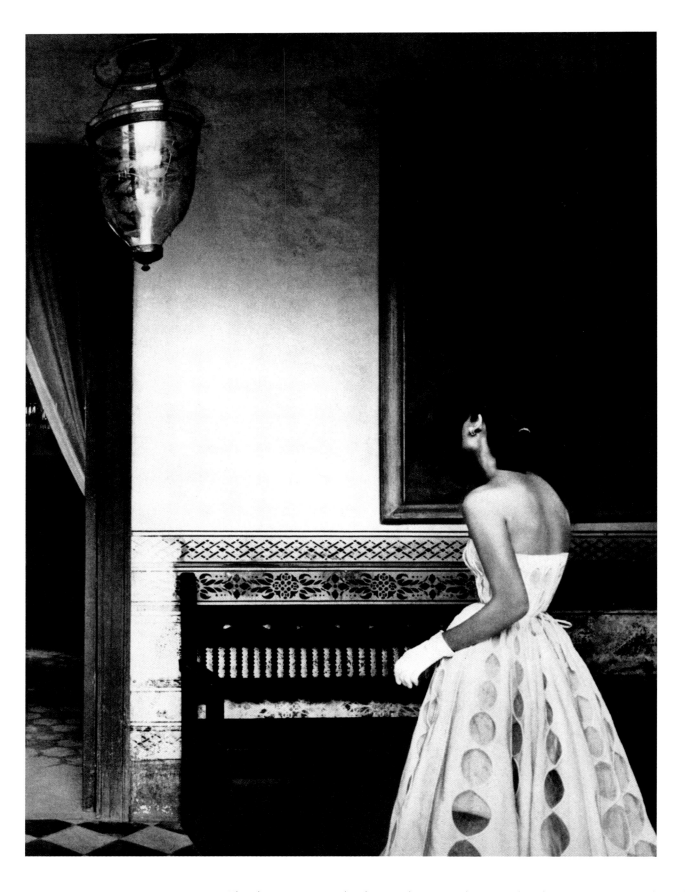

The elegant mansion that houses the Museo de Arte Colonial in Caracas, Venezuela, makes a charming setting for a Junior Formals gown of white organdy with exaggerated piqué appliquéd eyelets and a piqué rope sash tied at the back. Townes glovelets add the finishing touch to this enchanting dress. May 1953.

T o be asked to write about Gleb Derujinsky is not just an honor. To think of Gleb and his incredible interpretations is to stir a million memories of the golden years of high fashion and of a whole new world of fashion photography. Gleb was an early visionary on a path that others were to follow. We were good friends, we were young, and we spent endless wonderful hours together in New York and Paris. As his photographs show, Gleb knew intuitively that there was something in the realm of fashion waiting to be discovered. Gleb found the key to that world and followed his instinct to create something new and exciting, to which he brought an enchanting beauty for us all to share. We loved being a part of that world—Gleb's world.

EILEEN FORD, October 2, 2012

BELOW, LEFT Simone in a Dede Johnson cinnamon Forstmann wool dress. In her left hand she holds the image of Ruth used for the June 1960 cover of *Harper's Bazaar*.

BELOW, RIGHT Simone examines 8 x 10 Ektachrome transparencies, wearing a Marjorie Michael sheer gray Bellaine wool dress in the popular new two-piece look, hat by Lilly Daché, and Dawnelle gloves.

FACING PAGE Looking for the perfect image in a beige wool dress by David Barr for Fabiola with a Lilly Daché hat, Miriam Haskell earrings, and Hansen gloves, July 1960.

> "I have often been asked how I developed my style, and the more curious asked why."
>
> —Gleb Derujinsky

This book showcases the work of Gleb Derujinsky and the influences which inspired him to create images of art before fashion.

It was during the Golden Age of the incomparable *Harper's Bazaar* triumvirate of Carmel Snow, Diana Vreeland and Alexey Brodovitch that Gleb began his collaboration. The former Fashion Editor of *Vogue*, Carmel Snow was free as Editor-in-Chief of *Harper's Bazaar* to spread her wings and allow her imagination to soar. Mrs. Snow's vision of an elegant yet daring monthly book ignited a fire of inextinguishable creativity, and dynamic publisher William Randolph Hearst admired and encouraged her. She had an uncanny gift for seeking out and discovering new talent, and an unerring eye for art in fashion. Diana Vreeland, Fashion Editor, who would become known as the "High Priestess of Fashion", brought

to the magazine her exquisite taste, spirited thought, and vibrancy. The graphic design genius of Art Director Alexey Brodovitch revolutionized magazine layouts with his original use of white space and Surrealism. "[Vreeland] made the look, Brodovitch made those portraits of look flow through the book, Snow took care of upstairs and Seventh Avenue," Gleb recounted to Lisa Immordino Vreeland in an interview for the book and film *Diana Vreeland: The Eye Has To Travel.*

Haute couture designers were at the center of the transforming art form of fashion photography because each individual piece was a work of art. Carmel Snow loved the way Cristóbal Balenciaga's impeccably tailored garments flattered and enhanced a woman's figure. She was devoted to his designs, especially those with an innovative stand-away collar, and was instrumental in launching his career. After World War II, women's fashions transformed from conservative and tailored to a more feminine silhouette that was soft and flowing with romantic accents of ruffles and lace. In his very first collection in 1947, Christian Dior epitomized this emerging fashion shift with his "New Look". Style icon Coco Chanel continued designing uncluttered, practical styles for the modern woman of the 1940s onward. Her "little black dress" endures as a classic for all generations, and her signature suit is still considered a status symbol. Gleb had the privilege of photographing the exquisite creations of these and other top fashion houses that were well on their way to becoming the household names of today.

Gleb W. Derujinsky, Gleb's father, was a Russian aristocrat, elitist, and award-winning sculptor, who dismissed photography as nothing more than documentation, certainly not art. With passion and unbounded imagination, Gleb Jr. set out to prove differently. His early years of musical training and studies of various languages had already began to set the tone for Gleb's life that even his own father would not realize. Gleb would surround himself with artistic types from all media. His only criterion was that they be the best, placing high expectations on their contribution to the arts.

At age 14, Gleb was one of the youngest members of the prestigious Camera Club of New York, where he was under the expert tutelage of Edward Steichen and Alfred Stieglitz, known for their groundbreaking work in American photography. The brilliant graphic design pioneer Alexey Brodovitch gave young Gleb this advice, "If you see something you have seen before, don't click the shutter." Brodovitch's design elements would inspire Gleb throughout his entire career, whether he was shooting fashion, food, horses, or street people. Ewing Krainin, founding member of The Society of Magazine Photographers, counseled Gleb, "If you want to learn, pick a photographer whom you admire and a photograph you like, and copy it." The photographer Gleb chose was Horst P. Horst of *Vogue*. "Even now, I still feel he was the greatest", Gleb recalled later in his career. "HPH's lighting style carries over seven decades. It was his work I copied. Krainin had said that if the copies turned out perfectly, try another profession. However, if the copies change from the original, and do not resemble the original, and the picture is

interesting, you have a future. Fortunately, my copies were different. In doing this I learned a lot about lighting, framing, etc. And to this day I admire Horst."

In the years to come, Gleb Derujinsky's name would be added to the list of gifted photographers who proved that photography was indeed an art form. Edward Steichen, Alfred Stieglitz, Horst P. Horst, George Hoyningen-Huene, Man Ray, Cecil Beaton, Henri Cartier-Bresson, Lillian Bassman, and Louise Dahl-Wolfe were trailblazers in the field. Gleb and his contemporaries, Richard Avedon and Irving Penn, would gain worldwide notoriety unlike any before them. Avedon, Penn, and Derujinsky would then pave the way for the next generation of Melvin Sokolsky, Bill Silano, and Hiro.

Through his close relationship with Eileen and Jerry Ford of the Ford Model Agency, Gleb could choose to work with the very top models, many of whom set the standard for decades to come. He was captivated by Carmen Dell'Orefice, Iris Bianchi, Nena von Schlebrügge Thurman, Simone D'Aillencourt, Sandra Brown, Sunny Harnett, and Evelyn Tripp, the longest working model in the world. These iconic models are some of the most beautiful women in the world, and now new generations of fans are discovering these modeling legends.

A passion for beauty extended to Gleb's personal life as well. He married four fashion models, one of whom was my mother Ruth Neumann. Ruth was the love of his life during that period. They shared exciting escapades all over the world, many of which were captured on film and will endure forever.

After Gleb's service in World War II, his desire to travel internationally intensified. He wanted to revisit the cities he loved, like Paris, and he also wanted to discover the unique charm of those yet unexplored. Then he would be able to share these exotic locales in photos for all the world to adore.

Gleb's romantic view of life was translated into images with 180-degree peripheries. The entirety of the landscape, the model, and the fashion would inspire readers to muse, interact with, and become part of the photo. Imagine yourself walking the surreal landscape of the Nemrut Dagi rock sculptures in the Turkish mountains. Dare to dream! Imagine yourself at sunset in a floating restaurant in the Hong Kong harbor, smelling delicious, new aromas after a long yet glamorous flight. What would you be wearing for a trip around the world? Imagine yourself at Nara Park in Japan, gently feeding deer right out of your hand. Gleb's photos fulfilled the fantasy of travel to faraway places via fabulous cars, boats, ships, planes, and trains… all the while showcasing the wardrobe details to fashion lovers.

This is what you'll experience on the following pages. Exhale, for you will need to, as with each page comes a new breath to be taken in. I still feel that way, and I have seen these images a thousand times. I inevitably find a nuance I missed before, whether it's lighting, perspective, depth, or a bit of color so sparingly used between, 1950 and 1968. Now it is my pleasure to introduce Gleb Derujinsky, my father, the photographer.

ANDREA DERUJINSKY

MY
MOM
AND
ME

These pictures were published in the July 1962 edition of *Harper's Bazaar*, when I was eighteen months old, to illustrate an article about keeping skin youthful. Ruth told friends that she had been all round the world and now she wanted to be a mother. Gleb might not have been quite ready for fatherhood, but the images are stunning and filled with love: simple and universal images of mother and child. They were to be the first of many modeling jobs in my childhood.

ANDREA DERUJINSKY

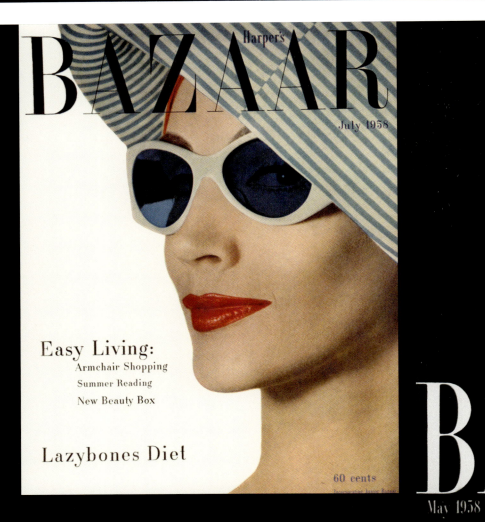

BAZAAR

Harper's

July 1958

Easy Living:
Armchair Shopping
Summer Reading
New Beauty Box

Lazybones Diet

60 cents

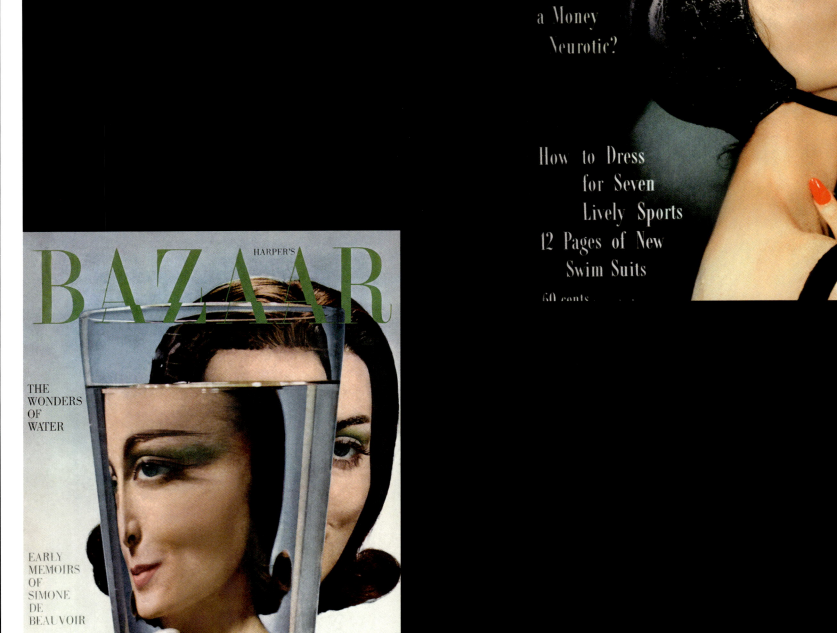

BAZAAR

Harper's

May 1958

Are You
a Money
Neurotic?

How to Dress
for Seven
Lively Sports
12 Pages of New
Swim Suits

60 cents

BAZAAR

HARPER'S

THE
WONDERS
OF
WATER

EARLY
MEMOIRS
OF
SIMONE
DE
BEAUVOIR

INSIDER'S
NEW YORK

MAY 1959
60 CENTS

HARPER'S

BAZAAR

AUGUST 1959
60 CENTS

SMASHING
CLOTHES
FOR
THE
GREAT
COUNTRY
LIFE

DYLAN THOMAS'
LOST
FILM
SCRIPT
COMPLETE IN THIS ISSUE

HARPER'S

BAZAAR

COLOR:
ITS
POWERS
OF
PERSUASION

HOW TO
LOOK:
VIVID
VITAL
VIBRANT

AUGUST 1960
60 CENTS

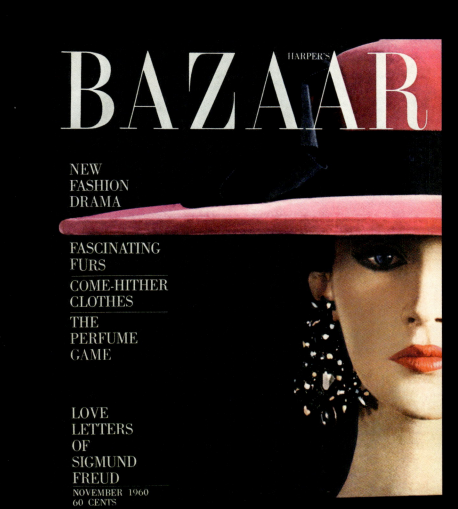

HARPER'S

BAZAAR

NEW
FASHION
DRAMA

FASCINATING
FURS

COME-HITHER
CLOTHES

THE
PERFUME
GAME

LOVE
LETTERS
OF
SIGMUND
FREUD
NOVEMBER 1960
60 CENTS

HARPER'S

BAZAAR

JUNE 1960
60 CENTS

COOL,
CALM
AND
COLLECTED:
DRESSES
FOR RARE
JUNE DAYS

COSMETIC
SURGERY:
UP-TO-DATE
REPORT

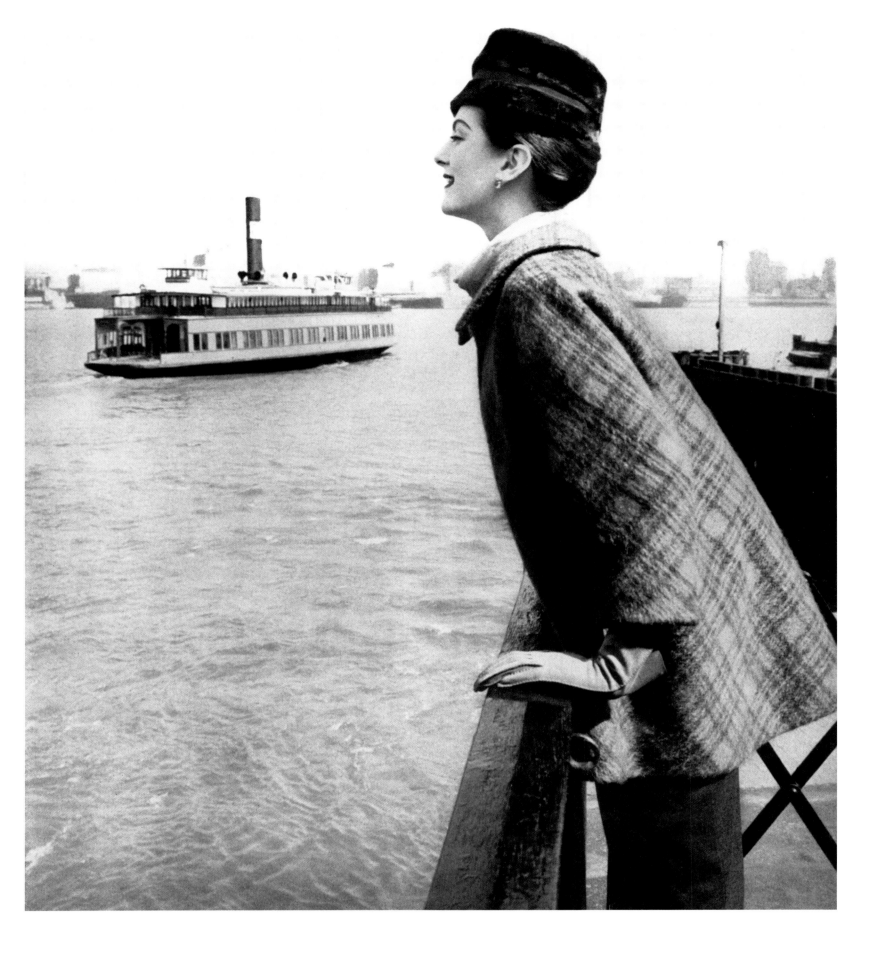

A sunny New York morning, a Hudson River ferry boat, and Carmen in fresh-off-the-runway red-and-green plaid steamer coat of light Sag-No-Mor wool jersey by Monte-Sano & Pruzan, July 1956.

IN THE BEGINNING

Surreal images of models with outsize wooden hands used as signs (courtesy of American folk art collector and dealer Mary Allis from Southport, Connecticut).

ABOVE Georgia Hamilton and Sunny Harnett model navy silk shantung sleeveless dresses with jackets by Aywon. Sunny wears a checked rayon twill jacket, also by Aywon. FACING PAGE Sunny Harnett modeling a black-and-white Swiss rayon tweed dress suit by Andrée, February 1952.

S outhern destinations offer a siren call to northerners to plan ahead for the winter. These summer fashions were ideal for warm, endless summers along the Mississippi, and for strolling through the gardens of the gracious Antebellum mansions of Natchez: residences such as the "The Elms", described on a sepia postcard as the "home of Mr. and Mrs. Joseph Bentley Kellogg," "Montaigne" with its colonnaded front porch, and "Melrose" with its inviting, lacy, cast-iron seat. Their elegant architecture, which miraculously survived the Civil War virtually unscathed, offers a nostalgic setting for the nipped-in waists and sweeping skirts that are once more in vogue in the early 1950s.

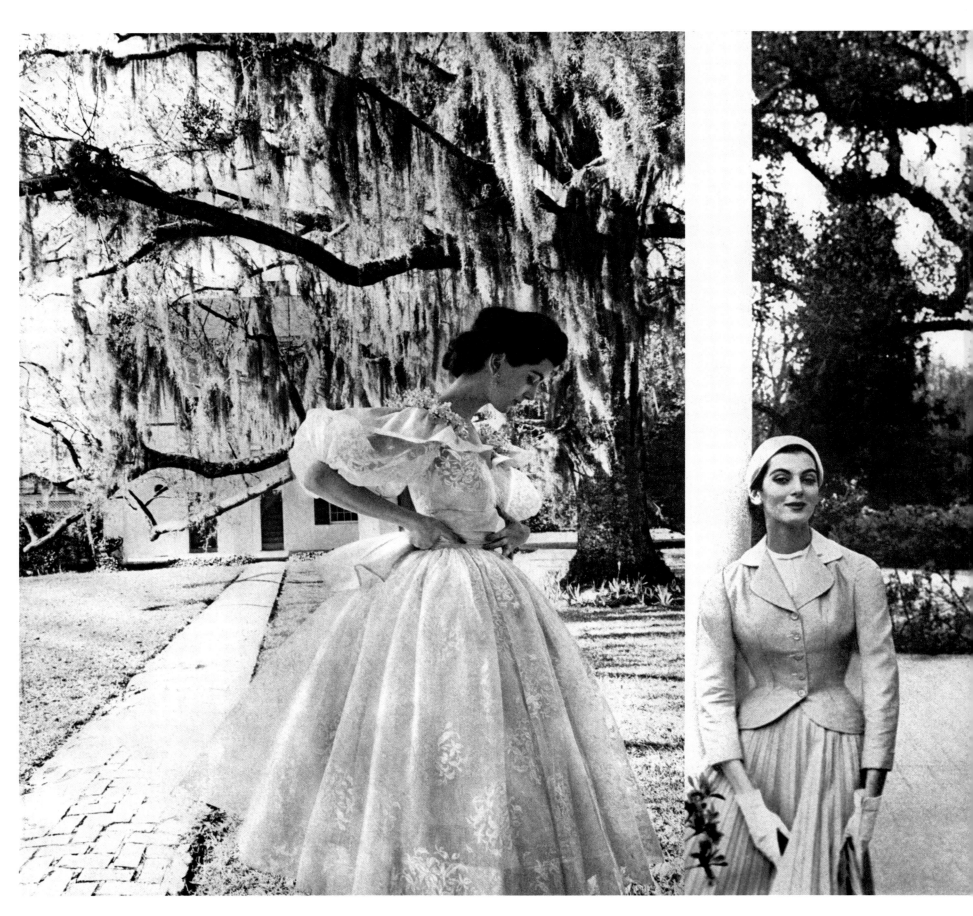

FACING PAGE Carmen Dell'Orefice brings the past into the present, strolling under trees festooned in Spanish moss that echoes the graceful lines of her divine short embroidered evening dress, in white organdy with a pale pink underskirt, by Howard Greer. She wears it with Miriam Haskell earrings, cool as a mint julep cocktail. BELOW Dressed for a day in town, a modern woman breathes in the scent of the lovely gardens that frame the stucco façades of "Montaigne." Carmen wears a Duchess Royal summer suit with a tweed appearance in the lightest orlon-nylon, with a linen collar and a permanent-pleat accordion skirt, accompanied by lady-like white gloves, June 1952. This is Carmen's first appearance in Gleb's shots.

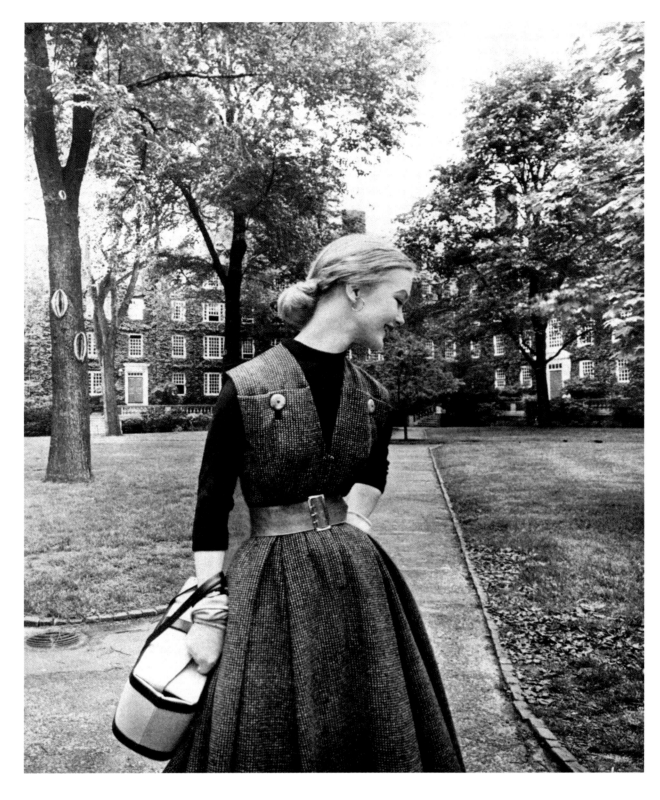

ABOVE This beautiful young woman with the tiniest waist wears brown-and-black tweed ("and tweed is a sound fashion," *Harper's Bazaar*). A jumper over a very chic black jersey shirt by Minx Modes (with no mention of the fabulous belt).

R

adcliffe can boast a long roll-call of distinguished alumnae, including the molecular biologist Nancy Hopkins, Jill Abramson, former executive editor of the *New York Times*, Anne d'Harnoncourt, Director of the Philadelphia Museum of Art, Caroline Kennedy, Benazir Bhutto, Margaret Atwood, and Helen Keller.

BELOW, LEFT The perfect outfit for dinner and a movie: a black jersey blouse with a Bates cotton tweed skirt by Toni Owen.
BELOW, RIGHT A new single-breasted polo coat by Donny Junior, worn with some of the most dreadful shoes I have ever seen: crêpe-soled brown lace-ups by Cobblers, August 1952.

"There's always more
than meets the eye in Gleb's
photographs; he chose each
location for its historical relevance.
So many places—like
the mighty Mississippi River
here—still hold so much
of their power."

—Andrea Derujinsky

FACING PAGE Carmen wears a made-to-order Valentina black faille alpaca cloak with bands of ivory moiré as she gazes
into the waters from the deck of the mighty Sprague steam towboat. Pearl drop earrings by Miriam Haskell
and long doeskin gloves by Aris, June 1952. Decommissioned to become a floating museum, restaurant, and theater
moored in Vicksburg. this great Mississippi sternwheeler was destroyed by fire in the 1970s.

FROM LEFT TO RIGHT Guardsman, in leaf-brown wool, by Rosenblum of California. Polo coat in Stroock wool and camel hair. Sandy fleece wraparound coat by Shagmoor. FACING PAGE High-collared, high-waisted, deep-pile, stone-colored fleece coat by Lumay, label of the year, August 1952.

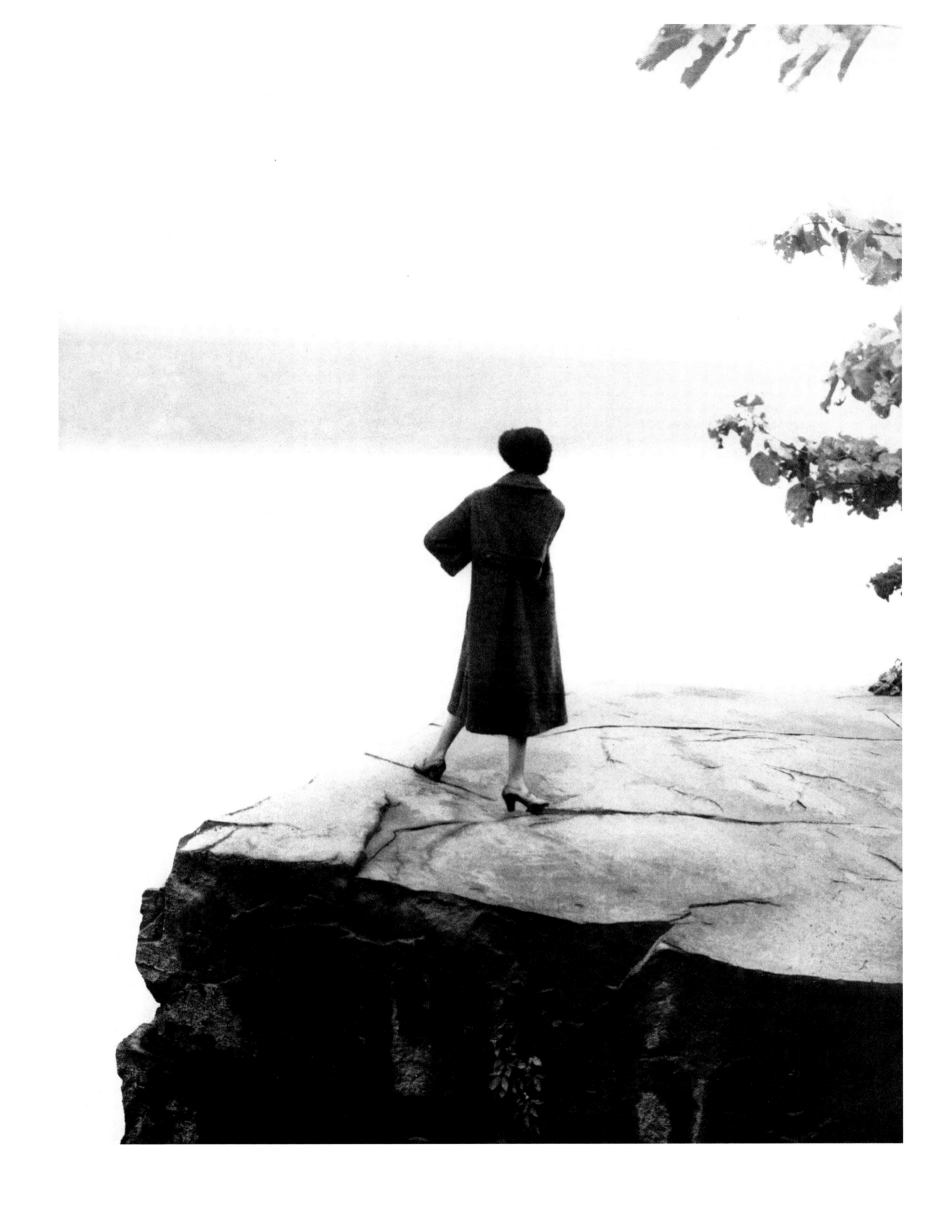

The San Blas Islands of Panama remain as remote a location today
as they were in 1952, an archipelago of three hundred and sixty-eight tropical islands and a paradise
of untouched nature and culture. After enjoying this pure, remote bliss, 1950s travelers could hit
the deck of the *SS Nassau*, the very first tourist cruise ship, and sail north to the Bahamas.

Don't forget to bring your suntan lotion, a brilliantly colored beach umbrella, and, naturally,
a panama hat (or three), specially made in Ecuador for Bergdorf Goodman, June 1952.

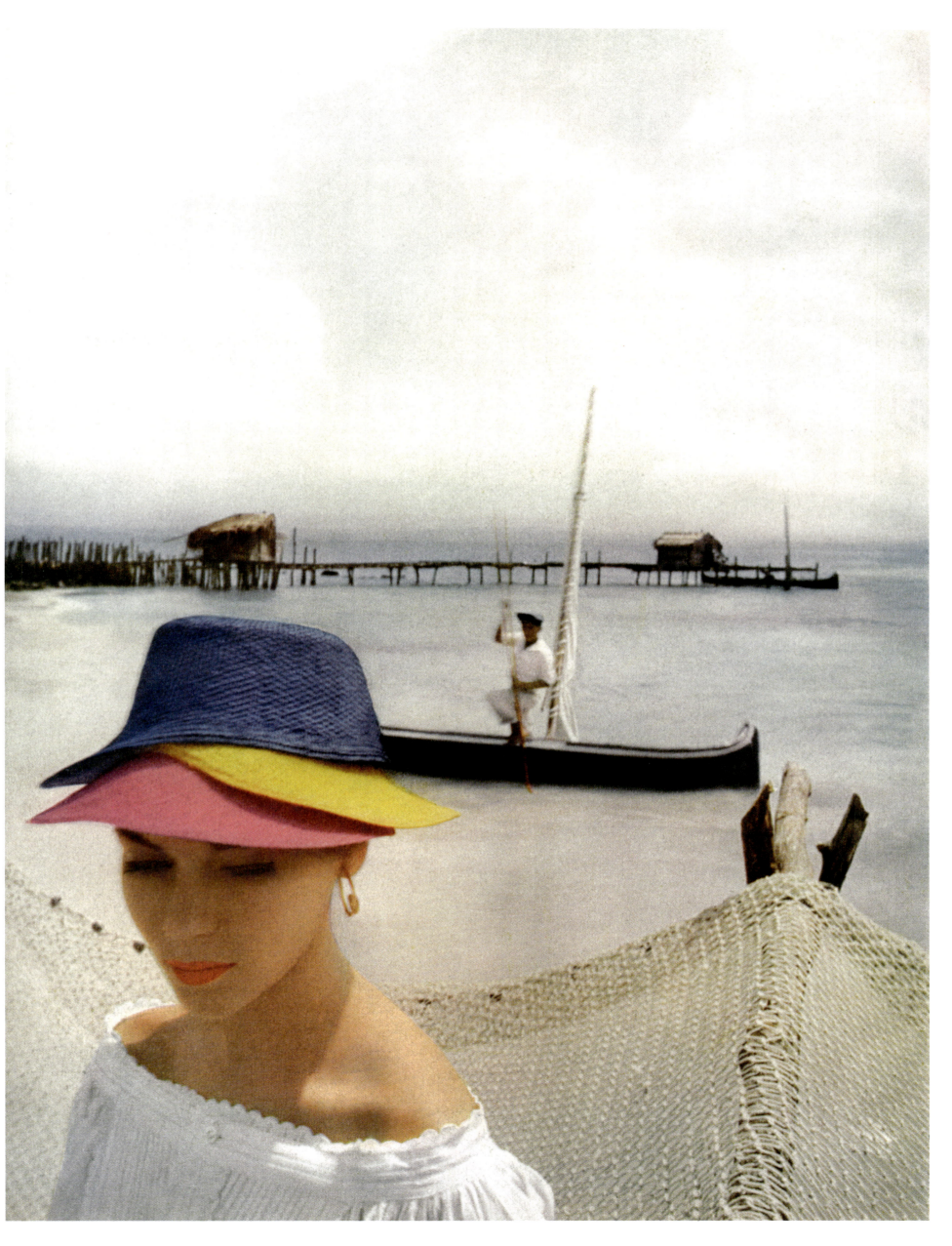

BELOW The Bahamas make a fitting setting for all things beautiful, especially in November 1952. The luxury of the Royal Victoria Hotel calls for pretty linen dresses wrapped with reverse-colored chiffon cummerbunds in moss, and lettuce green, by Horwitz and Duberman. The Royal Victoria Hotel, built in Nassau in the late nineteenth century, was the pinnacle of luxury, offering cocktails on the Starlight Terrace, fine dining, a fabulous swimming pool, and a magical tree house in its famous gardens. Today only the Royal Gardens survive.

FACING PAGE Green was the color for flying south for the winter, as in this harbor taxi ride for the lady wearing cool cotton by Junior Accent, November 1952.

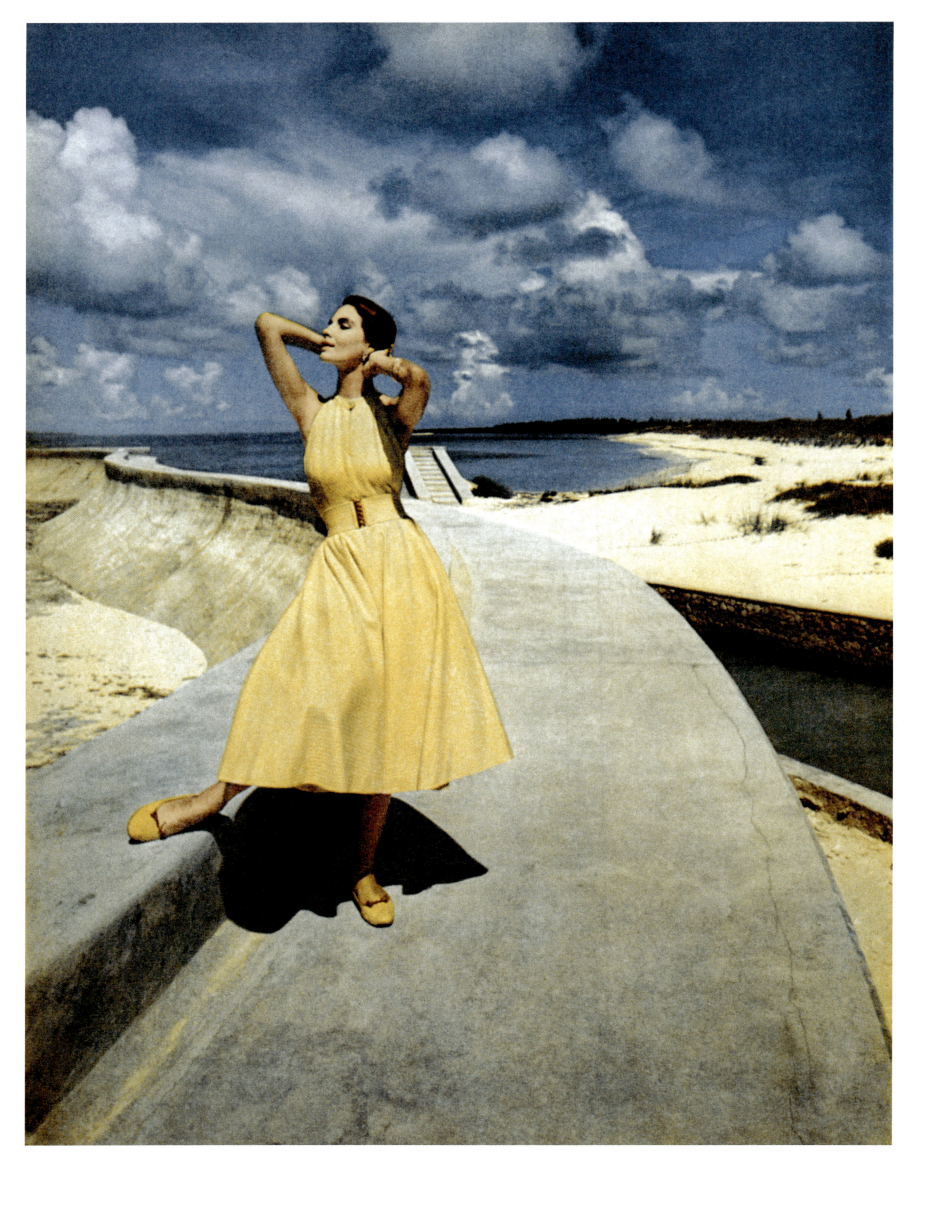

FACING PAGE Turn back the hands of time with a visit to what used to be known as Hog Island and is now the luxury resort Paradise Island. The serpentine jetty is part of the estate later owned by Huntington Hartford, who started the Huntington School of Modeling and Agency, later bought by Eileen Ford. *Thunderball*, starring Sean Connery as James Bond, was shot at this exact location thirteen years later, in 1965. The bleached palette of the beach and concrete walls complement this sand-colored halter top and full-skirted dress with a wide hook-and-eye belt, by Cabana. Naturally tanned Capezio pumps complete the look: a must-have for every glamorous traveler.

BELOW When you hit the beach in Paradise, Nassau, keep cool in the latest swim attire, in wool batik in green (naturally) and white, with a charming green chiffon beach shirt by Lotte of Drewyn, November 1952.

FACING PAGE "B" is for Beautiful, Broadway, and Babes. Gleb apparently had no hesitation in asking the girls to scale the ladders being used for renovations on the Bond Clothing Store building signage. The entire front of the building was covered with a huge neon sign featuring a 200-foot wide waterfall flanked by male and female figures which were apparently naked during the day, and clothed by lights at night. Our very brave girl on the left wears a dress in three shades of white wool and Stern and Stern chiffon with a grosgrain belt by Sportwhirl. The other fearless model sports a lace and wool dress by Greta Paltry. Their lovely pearl and rhinestone bracelets are by Miriam Haskell.

ABOVE Vertiginously suspended from the top of the Bond Clothing Store building on Broadway, in the glow of its neon lights, Sandy Brown wears a white silk layered organdie dress by Mollie Parnis, perfect for celebrating New Year's Eve in Times Square, December 1952. Behind her is part of the Simon Acherman Clothes Factory Store sign, with a huge 3D billboard advertising Budweiser beer.

The Great White Way, as Broadway was christened in about 1904, when the *New York Times* building was erected. Electric lighting was at the cutting edge of technology, and Broadway was lit up like Christmas every day of the year.

FACING PAGE Fast forward to December 1952, when white is the color of the season, and the fabric is chiffon, gathered, draped, and wrapped around the waist: pure Tanager by Bon Ray (left). The model on the right wears a sculpted chiffon evening dress by David Klein, the perfect foil for glistening diamonds to reflect the lights of Broadway. In the background is the colossal nude female sculpture on top of the Bond Clothing building.

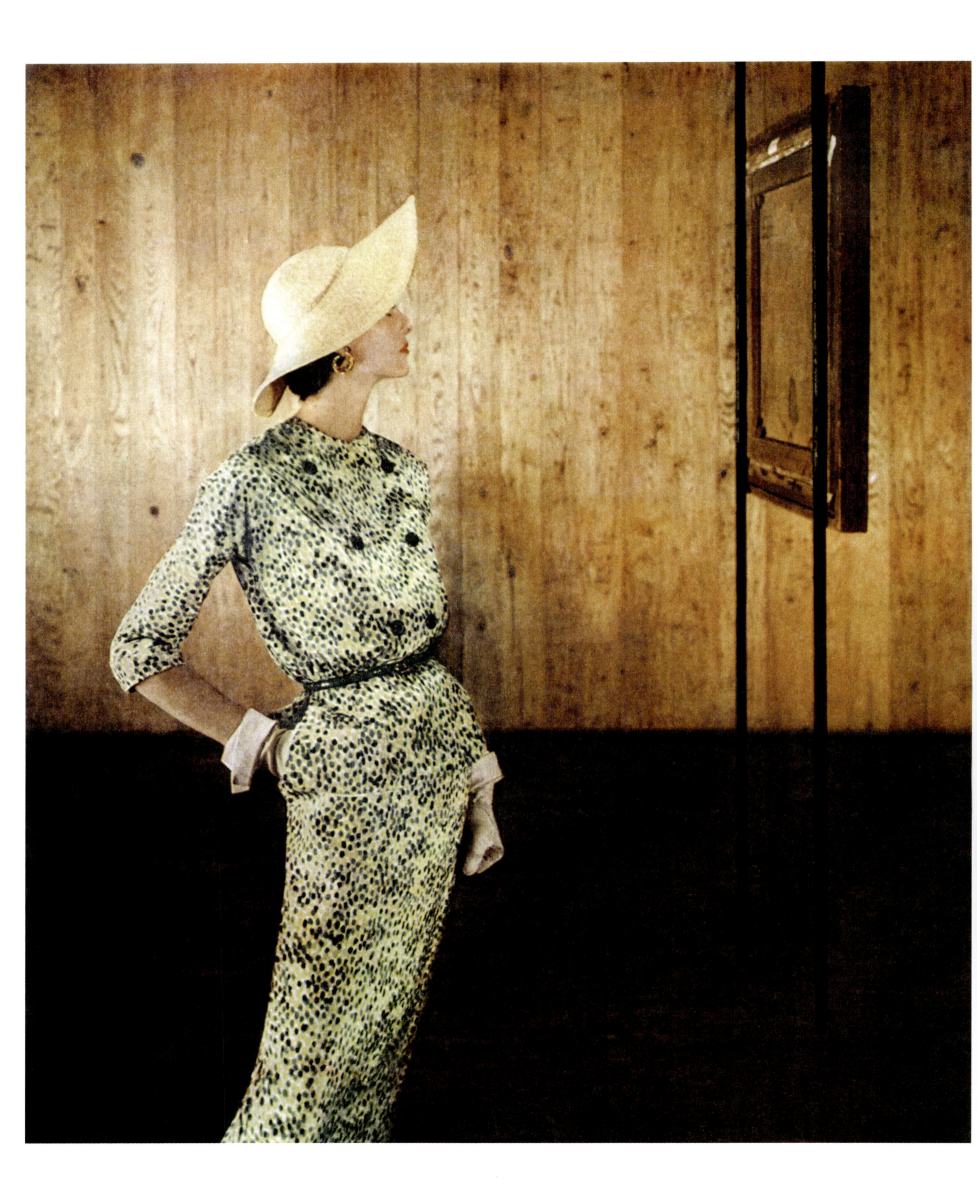

FACING PAGE Saunter through the rooms of the Alexandre Iolas Gallery to view artworks by Eyre de Lanux in a light yellow tunic jacket with dark green spots worn over a slim-line matching skirt in Burlington crepe. The honey straw hat is by John Frederics, the gold earrings by Schlumberger, and the green lizard belt by Midtown.

BELOW, LEFT Lime skin, this easy green suit in Botany wool by Leeds mixes a rough-textured jacket with a smooth-finished skirt. Monet earrings, Alexette gloves, and bright red Lasting Impression lipstick add the finishing touches.
BELOW, RIGHT Be a picture of elegance in an immaculately tailored Christian Dior suit in gray Worumbo flannel accessorized with Bendel Berry lipstick by Henri Bendel, March 1953.

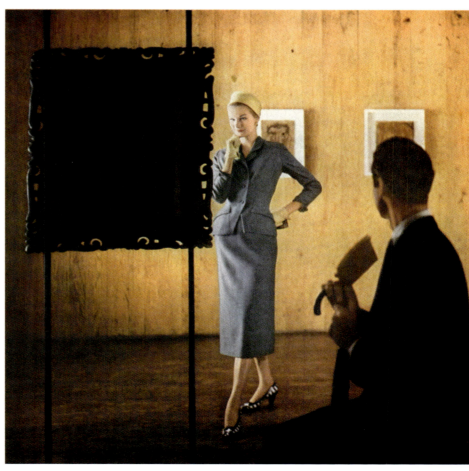

BELOW, LEFT Jackson Pollock paintings in the Sidney Janis Gallery provide a pioneering Abstract Expressionist
backdrop for a svelte navy blue suit in Onondaga crepe by Paul Parnes, with widely spaced polka dots on
the white surah collar and cuffs, complemented by a white Lilly Daché hat and Evins pumps.
The Bertoia chair by Knoll Associates—patented just a year earlier by Harry Bertoia—has stood the test of time,
and, like the art on the walls, pays tribute to the prescient eye of Sidney Janis and the New York art community.

BELOW, RIGHT Everyone got what they wanted in this one perfect shot. Diana Vreeland sold the dress, *Harper's Bazaar*
Art Director Alexey Brodovitch showed the art, the model became a mannequin, and a priceless moment perfectly lit creates
an immaculate fashion photo. The sharply chopped off red jacket is a stand out, worn with a fitted high-waisted skirt
by Lo Balbo, and topped off with a John Frederics hat.

ABOVE The Giacometti sculptures are on display in the New York gallery of Pierre Matisse, son of Henri. Indulging in a casual cigarette in this illustrious company takes chutzpah—or perhaps you can get away with anything in this coolly sophisticated Italian silk pinstriped jacket and narrow skirt by Willi, worn with gloves by Grandoe and a charming black hat by Madcaps, February 1954.

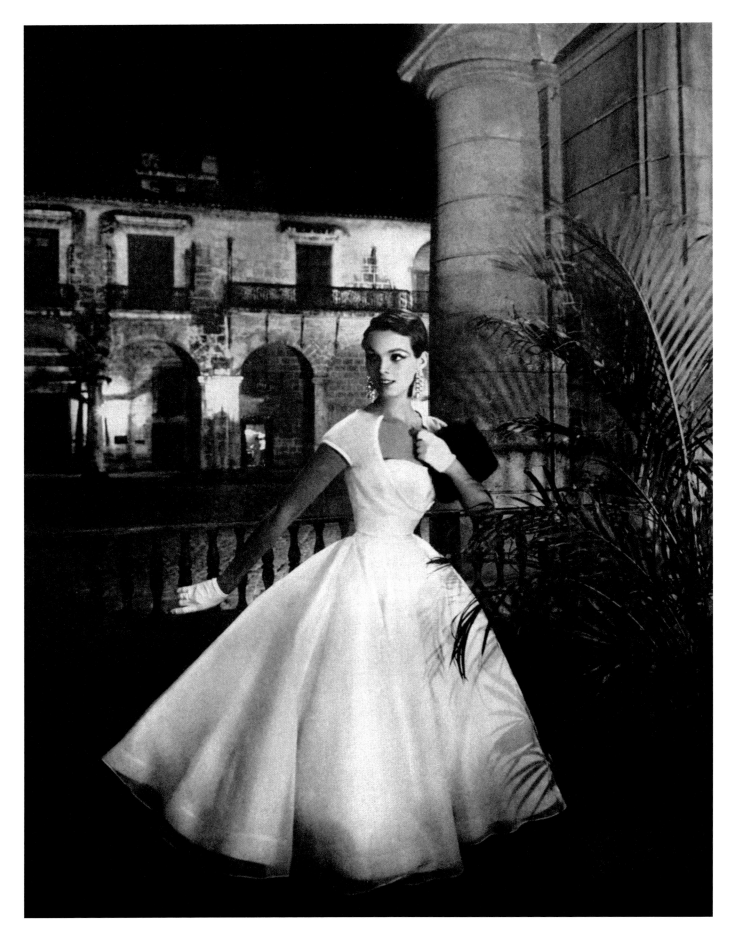

ABOVE At the heart of Old Havana lies the Plaza de la Catedral, with its lovely illuminated arcades. Warm Cuban nights call for a romantic dress by Jo Copeland, with sweeping skirts of full white Bianchini silk organza, the bodice draped around a guimpe, a hint of sleeve, and finished in the back with a single fabulous red rose. Diamond earrings by Baron Joseph "Sepy" De Bicske Dobronyi, a talented jeweler and Gleb's good friend.

F

rom the 1930s to the 1960s, the Hotel Nacional de Cuba was a glamorous
destination with a stellar guest list, including movie stars and presidents, athletes and writers, mobsters and royalty.
Frank Sinatra, Tyrone Powers, and Marlene Dietrich stayed here, as did Winston Churchill and numerous presidents,
and Hemingway downed Bacardi daiquiris while taking in the panoramic views of the city and the Gulf of Mexico.

BELOW This bilaterally buttoned ready-to-wear Sophie Originals Peasant dress, a coolly composed column of
white grainy-textured silk, would be just the thing for a chic winter getaway, January 1954.

"Avedon shot dresses and clothes, Gleb shot women living in them. Gleb had a determination to have it his way, not the client's way, or the editor's. What he saw and photographed was what he thought it should look like. He wasn't appreciated for this character trait, as he didn't kowtow to others' whims. Gleb would most likely not win most popular. He just didn't fit in."

—Bruce Clerke, Fashion Assistant Editor, *Harper's Bazaar*

FACING PAGE Jean Patchett, darling of the American fashion world, admires French, Venetian, and English provincial furniture at Roslyn Rosier's Town and Country Shop, located at 40 East 57th Street, looking the epitome of freshness and sophistication in a lace strapless top and column-style skirt in ivory nylon over Celanese acetate taffeta, by D. Strauss (Simplicity patterns 4320 and 4792), worn with imposing earrings by Nettie Rosenstein, July 1954. This was one of the rare occasions when the model did not do her own hair and make up: smooth hairline coiffure by D.J. Brown House of Beauty.

The ability to see beauty right in your own backyard is just as important as spotting it in more exotic places. Columbus Circle was an historic location in Manhattan, and photographing its pigeons in this era of peace and progress may have been Gleb's way of paying homage to the surprising service of carrier pigeons in wartime.

BELOW, LEFT Ben Zuckerman's raspberry Anglo wool tweed walking dress, fully lined and with matching raspberry satin at the neckline, waist, and wrists, is beautifully tailored and perfectly complemented by a black velvet mushroom hat by Tatiana and David Evins shoes.

BELOW, RIGHT Monumental new looks with longer jackets began to make their appearance in the mid-1950s. Here, the sun shines brightly on the fashions of a new era. This Larry Aldrich camel-colored doeskin 28-inch jacket, worn over a slim skirt with a white satin blouse to match the lining, strikes a suitably sober note in front of the USS Maine National Monument at the Merchants' Gate entrance to New York's Central Park, August 1955. The monument commemorates the two hundred and sixty American soldiers who died when the battleship Maine blew up in harbor at Havana in 1898, the event that was responsible for starting the Spanish American War. The campaign to raise a monument, started by William Randolph Hearst, was one of the largest fundraisers of the time, and it was not dedicated until 1913.

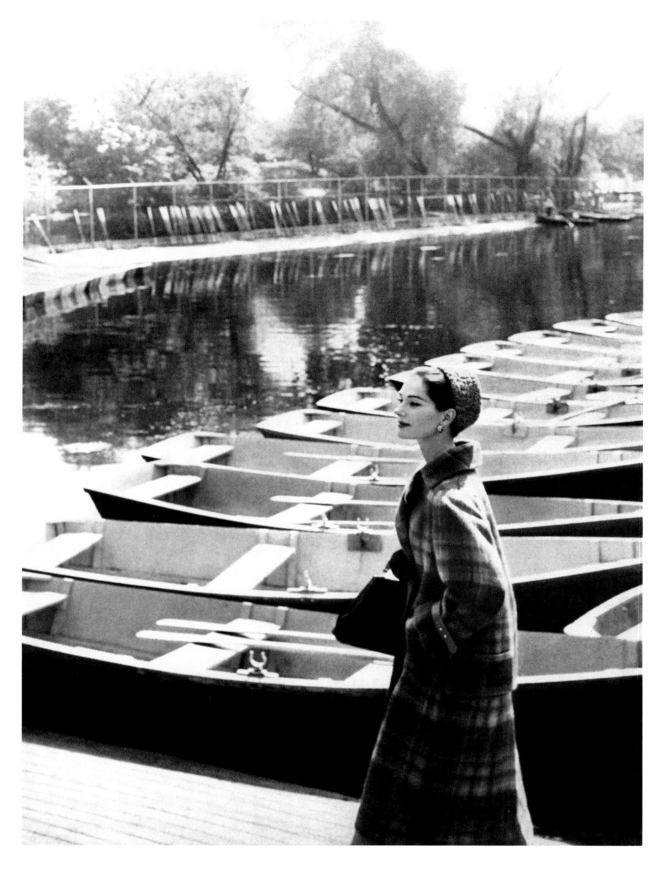

ABOVE As fall turns to winter, this lovely topaz plaid brushed wool coat by Anthony Blotta is perfect for keeping warm beside Central Park's 22-acre boating lake, beloved of New Yorkers and visitors alike. Handbag by Josef, September 1955.

BELOW Ruth Neumann (left) made her Derujinsky debut in this advertisement for Greta Plattry summer wear.
Although she had been honing her modeling skills with the likes of Irving Penn, Mark Shaw, Roger Prigent, and Horst P. Horst
for several years, Gleb's first images of Ruth did not appear until January 1956.

FACING PAGE A hoodie and boy shorts or a sarong over a two-piece swimsuit, all finished off with charming
gold flats, says tropical! Sportswear designer Greta Plattry was famed for her sophisticated designs for sun
worshippers, featuring her signature "exotic" border prints. January 1956.

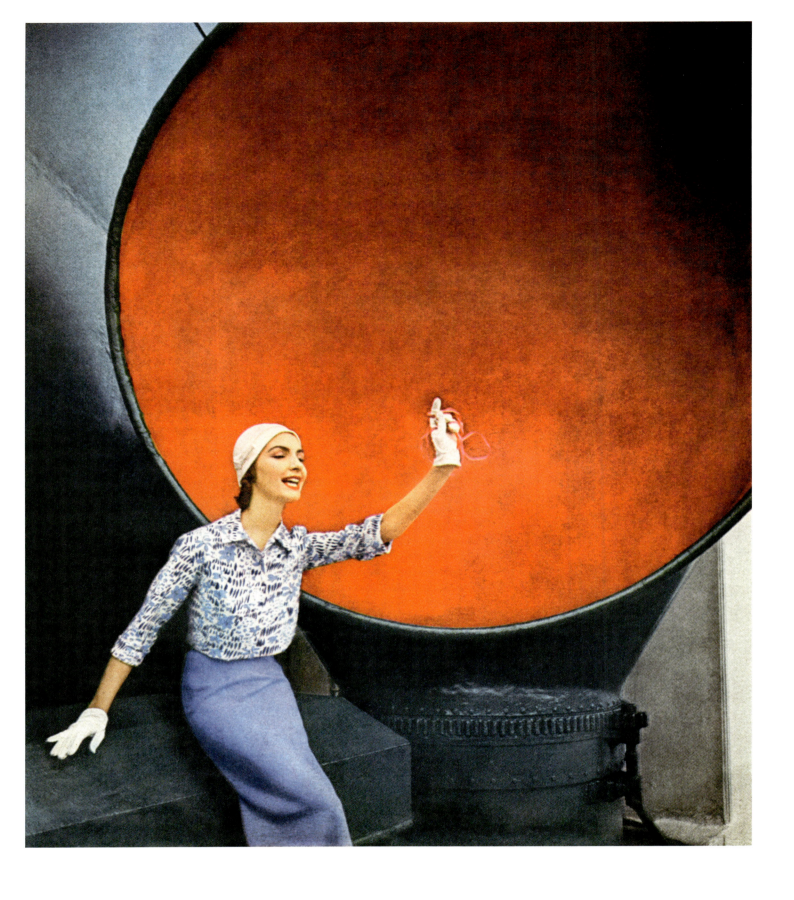

ABOVE Cruise into 1956 in style on the *SS Santa Paula*, cool and fresh in a blue-and-white
dappled Moygashel linen pullover top, worn long or lopped off, with a periwinkle-blue linen pencil skirt.
Wear Right gloves add the finishing touch for traveling in style.

FACING PAGE Passenger flights on New York Airways Sikorsky S-55 helicopters made commuting from LaGuardia to Idlewild Airport (rededicated as JFK International in 1963) a ten-minute breeze. Travel and fashion were about ensuring comfort for the flight and style for your arrival in your new destination, starting with a chic entrée on the tarmac. The girl on the go could feel radiantly confident in this snappy wool and mohair tweed belted-jacket suit with a matching wide tasseled scarf, both by Davidow, teamed with a satchel bag by MacArthur and I. Miller shoes, February 1956.

BELOW Commuters could cross the Hudson River from New Jersey to Upper Manhattan via the George Washington Bridge, familiarly known as the GWB, take the train, or cross by ferry with the car. And if that car happened to be the brand-new Ford Continental Mark II (one of a limited edition of just four thousand) you would be the envy of all. In high summer, early morning was the only practical time for shooting warm and cosy coats for the Fall/Winter season—here, a nonchalantly chic, high-belted brown suit in Forstmann flannel by Harry Frechtel.

FACING PAGE A list of all-time dream cars would have to include—alongside the great American classics featured in Gleb's fashion shoots—this Citroën DS 19, as revolutionary in its technical specifications as it was glorious in its design. With his unerring eye for the finer things in life, including cars, Gleb paired this classic beauty with the Lackawanna Railroad ferry. A chic traveling outfit featuring a Jerry Gilden silky flyaway cardigan in green and red cotton surah, worn over a sleeveless black cotton and rayon scoop-necked dress and topped off with a Nefertiti crown hat by Adolfo of Emme completes the stylish picture, July 1956.

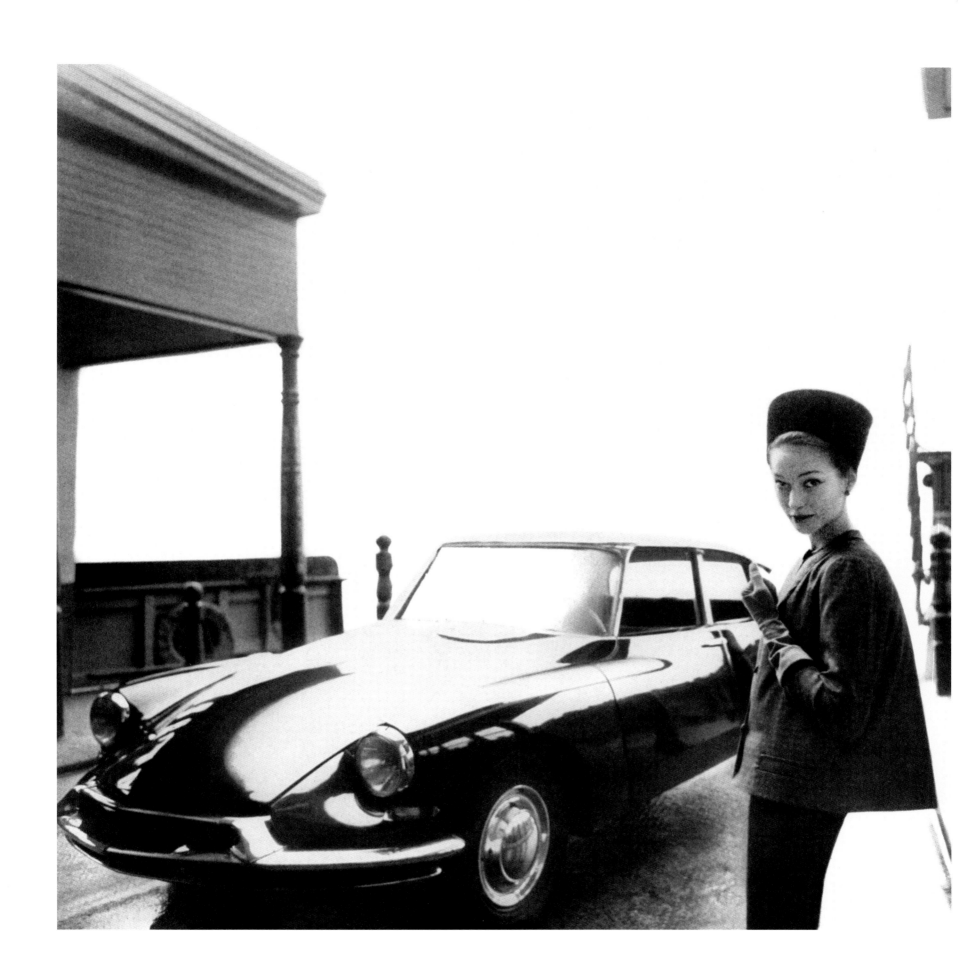

CARMEN DELL'OREFICE REMEMBERS...

Compellingly good looking, this gorgeous new kid on the block missed many jobs that he had me booked for. The client had to pay me anyway, but if the winds were right for gliding it didn't matter what the job was, no contest; he'd be up in the air gliding around Connecticut. … and over Bobby Said's animal farm. Despite being his own worst enemy, he was charmingly irresistible, especially to a model friend of mine named Ruth Neumann, nickname "Root", whom he married eventually, had two daughters with, and, sadly, divorced. I never got his pictures mixed up with Avedon's at all, or with any one else's for that matter. Gleb's style was undeniably his own. He always had an affinity with the outdoors, and being on a location shoot was his bailiwick. He came from a Russian cultured, artistic, family. Creativity was in his genetic make up, as were his intense brown eyes, and thick black eyelashes. I had worked with him for *Look* magazine, *McCalls*, and many others I can't even remember the names of, fifty years later. (It was to the best of my recollection the year 1957 when he asked me to do the Paris collection with him for *Harper's Bazaar*. I said yes) Because I was used to working with him and was very close to Ruth, whom he had married by then, we three worked very harmoniously together.… He never had to copy anyone. He had his own vision, knew his equipment, saw light and the environment in his own unique way. He made me feel that I was part of a vision he was seeing in his mind and making manifest in a still photograph. I always thought Ruth, myself, and certain editors helped him understand how to appreciate couture, and also women, differently than he was used to doing. Gleb Derujinsky, you little devil, thank you for all the divine "iconic" pages we did together for posterity! Your buddy in life and ever after, with fond memories and love.

FACING PAGE, TOP This was the first of Gleb's photo shoots featuring both Ruth and Carmen, taken in Pound Ridge, Westchester County, New York, with the cheetah provided by family friend Bobby Said, who owned the estate. Looking radiant in the sunlight that streams through the willow branches, Carmen wears an over-sized toast-colored turtleneck mohair sweater and matching wool jersey skirt by Goldworm, the 1956 winner of the Woolknit Award.

FACING PAGE, BOTTOM Ruth and Gleb got married on May 30th, 1956. In this August shoot he captured her basking in the rays of the sun with another creature of feline grace, and preparing for fall in a natural unbleached ribbed turtleneck sweater worn over a Loden cloth skirt in olive green, by Glen of Michigan, August 1956.

FACING PAGE November 1956 saw the first previews of the 1957 Lincoln four-door sedan, with a capacious trunk for all those bags for your cruise to the Med! This image is a masterpiece of composition, with the giant hull of the ocean liner, the cobbled quayside, and a couple of trestles supporting the wooden ramp up onto the ship's car deck. Equally graphic are the clean slick lines of the Samuel Roberts white kidskin slim pants, with pullover top and sweater by Dalton of America.

BELOW Sunglasses are de rigueur on board *MS Giulio Cesare* in the port of New York, alongside the gleaming white *MS Cristoforo Colombo*, two of the latest Italian cruise liners. The sheath dress in mimosa yellow worsted with three-quarter sleeves is complemented by a silk scarf by Vera, November 1956.

ne Wall Street (now the BNY Mellon Building) was the august address of the Irving Trust bank (named after the distinguished man of letters Washington Irving) until 1988.

FACING PAGE Pictured against the sleek limestone-clad façade of the Art Deco-style building, Ruth (on the right) wears a two-in-one reversible coat in smooth black leather and spotted skunk, by Bonnie Cashin for Philip Sills at Marshall Field. Her companion wears a coat in black antelope and American raccoon, and both outfits are topped off by hats by Adolfo of Emme, November 1956.

ABOVE, LEFT The triumphant threesome having fun modeling and photographing swimsuits on Bobby Said's estate in Pound Ridge.
Carmen wears an acetate bengaline swimsuit woven with Lastex, pure white and unadorned, by Rose Marie Reid.
It looks like Gleb combined this shoot, published in December 1956 and making exhilarating use
of the home-made shower he rigged up beneath the willows, with the earlier sweater shoot, also at Pound Ridge.
ABOVE, RIGHT Carmen keeps cool in a starfish-patterned Cole of California lace-up suit made of Helena nylon, which dries in a flash…

FACING PAGE …while Ruth models a black Carlton Mills wool jersey low-cut halter-neck suit with
a checked lining to match the Springmaid cotton blouse hanging on the tree, December 1956.

The architectural delights of Paris: a dusting of snow on an early spring morning, a wrought-iron balustrade overlooking the Seine, and a gown exemplifying Pierre Balmain's "architecture of movement": a delicate confection of pale gray lace and delicate gray and pale pink roses cascading from waist to floor, April 1953.

PARIS
COLLECTION

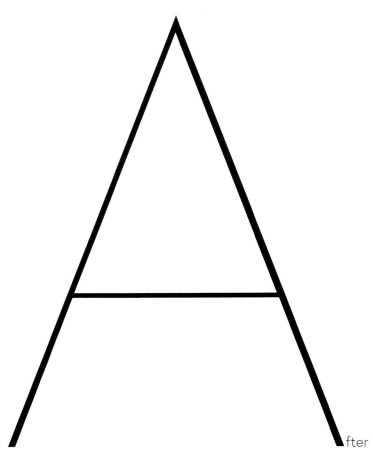

After working for *Harper's Bazaar* for about five years, I was asked to photograph the collections. I arrived in Paris in a panic! Every corner had been used by Dick Avedon, Louise Dahl Wolfe, Karen Radkai, and others, including the *Vogue* photographers, and I knew that such obvious surroundings like as the Arc de Triomphe, the Eiffel Tower, the bridges across the Seine, and others had been done, and well done. I began a search for something new, and found it in an old book store on the Left Bank: an old picture book with photographs taken in the late eighteen hundreds of the *petits métiers*, the assorted mundane tasks found around Paris. The photos were of people sweeping the sidewalks, lamplighters, a man surrounded by goats in Montmartre, the bird lady at the flea market.

I realized that those small tasks were still being performed, and if I cycled my fashion models in this atmosphere and shot in a documentary style, picking the climatic moment, I would be preserving history in the making. Real people, real faces reacting to me and my models. A completely different fashion photograph. Real people are never boring.... I am not saying the models weren't real people, they were real and carefully chosen by me. They had a very difficult part to play. The highly accepted models of the time could not have contributed to the pictures like the models I chose did. They had to be able to show off the styles of the moment. All these photos had to be reportage of the new designs, hem lines, waists, hats, shoes, to complement those elements while reacting to the situations they were drawn into. Without [the models'] talent I could not have succeeded. **GLEB DERUJINSKY**

ABOVE Perfectly dressed for a matinee at the Théâtre National Populaire,
Iris Bianchi wears a mauve wool-and-linen suit with a mauve chiffon blouse
and matching hat by Dessès.
LEFT A street painter sets off down the famous steps of Montmartre
to start his day, his smart beret echoed by Ruth's Dior beret embellished
with spring flowers, which complements a charming suit in gray
Prince of Wales plaid. Iris wears a mauve wool tweed suit with Garrigue
buttons and a violet straw hat, March 1958.

BELOW, LEFT The 1958 Spring collections were the dawn of a new age for Dior. Before his death the previous October, Christian Dior had anointed his successor: the twenty-one-year-old Yves Henri Donat Mathieu-Saint-Laurent. Yves Saint Laurent's designs were greeted with praise this spring, and if his time with the House of Dior was short, his success would be lifelong. In this photograph taken outside the Lapin Agile cabaret in Montmartre, Ruth models YSL's "Trapeze dress," his first ever hit for the house of Dior: history in the making.

BELOW, RIGHT Old Montmartre meets the latest fashions: a pungent encounter between the cheese seller in Place du Tertre with his friendly goats, and Carmen in a one-piece dress with a two-piece look by Madame Grès, in Labbey's brown-and-white checkered tweed, with a silk turban, March 1958.

ABOVE Carmen in a Chanel suit from the 1957 Spring/Summer haute couture collection, in gray-beige wool by Leonard, with blouse and lining of printed garden pink silk by Labbey. Kislav gloves, March 1957.

FACING PAGE The lamplighter on Place de la Concorde (the Statue of Lille framed by his feet) gives Carmen directions, while her pose—in new bright coral coat and black beret by Dior, March 1957—echoes the shape of his round-pole ladder, like the ones traditionally used for picking fruit in orchards. The small boy peering out of the window of the passing 1957 Citroen 2CV might almost be whispering Robert Louis Stevenson's poem "The Lamplighter."

BELOW, LEFT Striking a nonchalant pose in a Chanel suit from the 1960 Spring/Summer haute couture collection, made of soft camellia-white wool, with little white pompoms at the neckline and silky black braid trim. Chanel No. 5 makes the perfect accessory.
BELOW, RIGHT Madame Grès white jersey Veron wool dress, tightly wrapped in a dark willow-green silk cummerbund.
The coiffures in this sequence of photos taken in Paris in the spring of 1960 were by Alexandre de Paris. Gleb had made many friends on his visits to Paris over the years, and he loved to go back to his favorite spots to shoot and dine, catching up on the latest news and doubtless share his adventures. The venerable restaurant Lapérouse has been entertaining artists to the elite since 1766, and although it has undergone many changes, it still retains much of its iconic charm.

FACING PAGE In the 1920s, the monumental bewhiskered features of "Docteur Pierre" (in reality Dr. Pierre Mussot, the canny founder of an early toiletries company) could be seen advertising his famous toothpaste on tall buildings all over Paris. Here, once again, Gleb has convinced a model to clamber up to a vertiginous spot clad only in high heels and haute couture. But what better way to advertise this lovely Dior over blouse dress in black wild Honan silk by the Zurich-based silk company Abraham? March 1960.

"He was wonderful to work with and he was kind of a 'bad boy,' you know? Naughty but nice."

—Carmen Dell'Orefice, model

FACING PAGE Place Vendôme hosted some of the most exclusive boutiques and hotels in Paris in 1958, including A. Sulka & Company, long-vanished men's Haberdasher to Royalty. As a trio of cheery postmen deliver the day's mail, our model strolls under the iconic arcades in an inky black afternoon dress by Yves Saint Laurent with a brief bolero top in wool-and-silk by Staron, under a Dior black straw hat lined with white petals, March 1958.

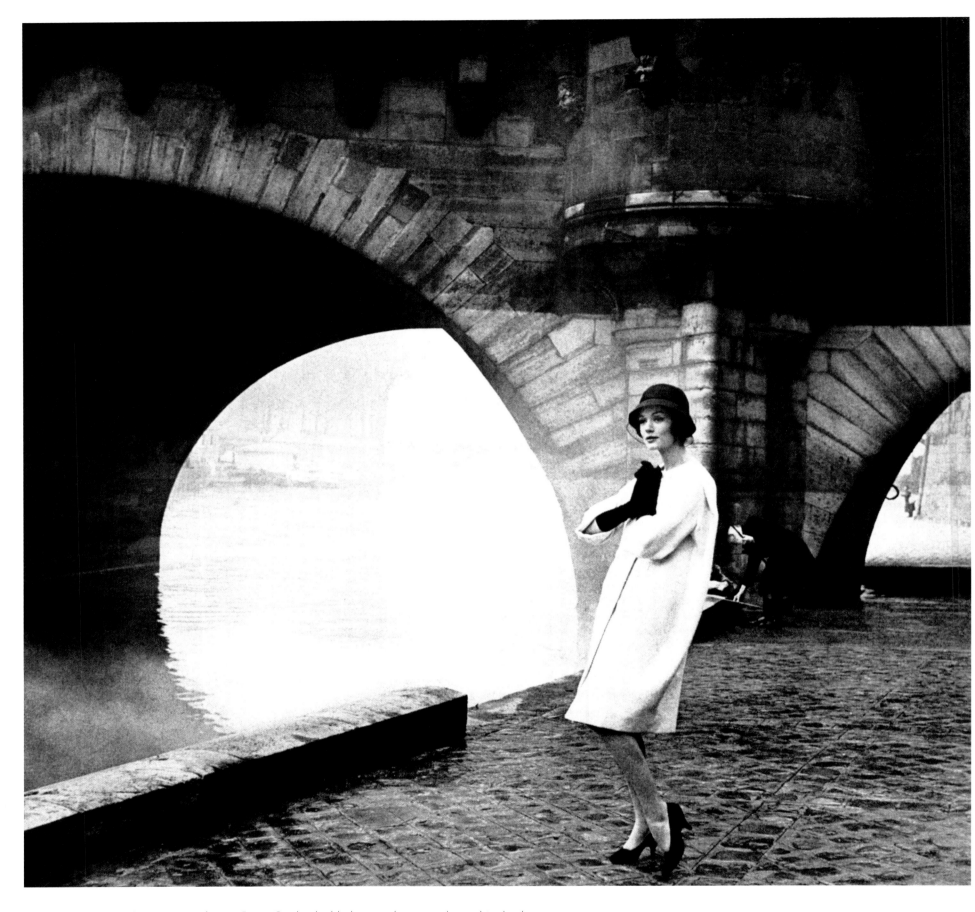

ABOVE Simone in an elegant Pierre Cardin double-breasted coat made in white basketweave
wool by Fournier with a black veiled cloche, with the fisherman behind her.

FACING PAGE Fishing on the banks of the Seine: Simone D'Aillencourt in Lanvin-Castillo's
top coat (one of the great successes of this collection) made of weightless Ascher's brown
nylon-and-wool tweed, shadow-crossed in white, complemented by a white straw
cloche by Lanvin and Arpège perfume, March 1958.

ABOVE The Arc de Triomphe provides a bird's-eye view of Paris, the distinctive curves of its parapet hinting at the location. Balloons and navy blue tweed by Dior on a gray day: what could be more chic?

FACING PAGE Early morning sunshine on a light silk day coat and hat by Dior, in one of the very few shots Gleb ever took that included the Eiffel Tower, March 1957.

"There is so much romance in his images that his personality really comes out in them, his sense of adventure, that he loved to do daring things, do something different, and be in the moment."

—Andrea Derujinsky

FACING PAGE Reflections of Place Vendôme: the lamplighter's ladder and Ruth's own elegant profile frame a beige Lahondes tweed suit by Chanel from the 1957 Spring/Summer haute couture collection, and a deeper beige surah blouse by Petillault, in a fascinating play of chiaroscuro and architectural detail, March 1957.

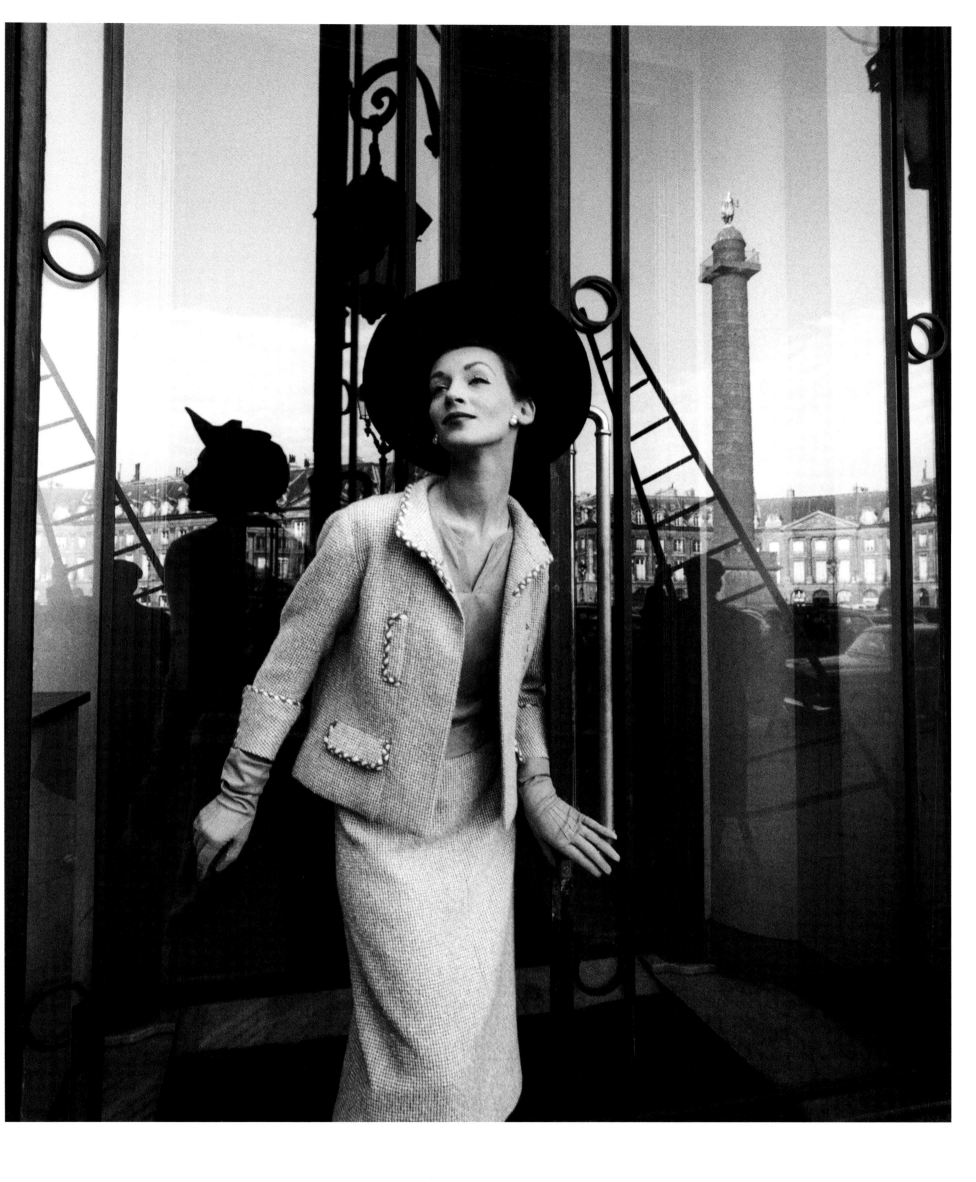

BELOW The most beautiful bride in the world wears Patou. The bodice is of encrusted guipure lace, while yards of white piqué create a heavenly skirt and squared veil, the latter anchored by a piqué toque. Meanwhile, the marching band gets into the swing (we like to imagine) with Mendelssohn's *Wedding March*.

FACING PAGE This Lanvin-Castillo wedding gown is all about tulle, custom-tailored by Bianchi at Bonwit Teller (Julius Garfinckel and I. Magnin could also tailor a copy). The coiffures in these bridal shots are by Alexandre, April 1960.

As Ruth wafts through the Jardin des Champs-Élysées in this Dior
black Robert Perrier silk organdy evening dress layered over white chiffon and
finished with a black velvet ribbon, it's as if the early morning mist is filled
with Diorissimo perfume, March 1958.

83

83

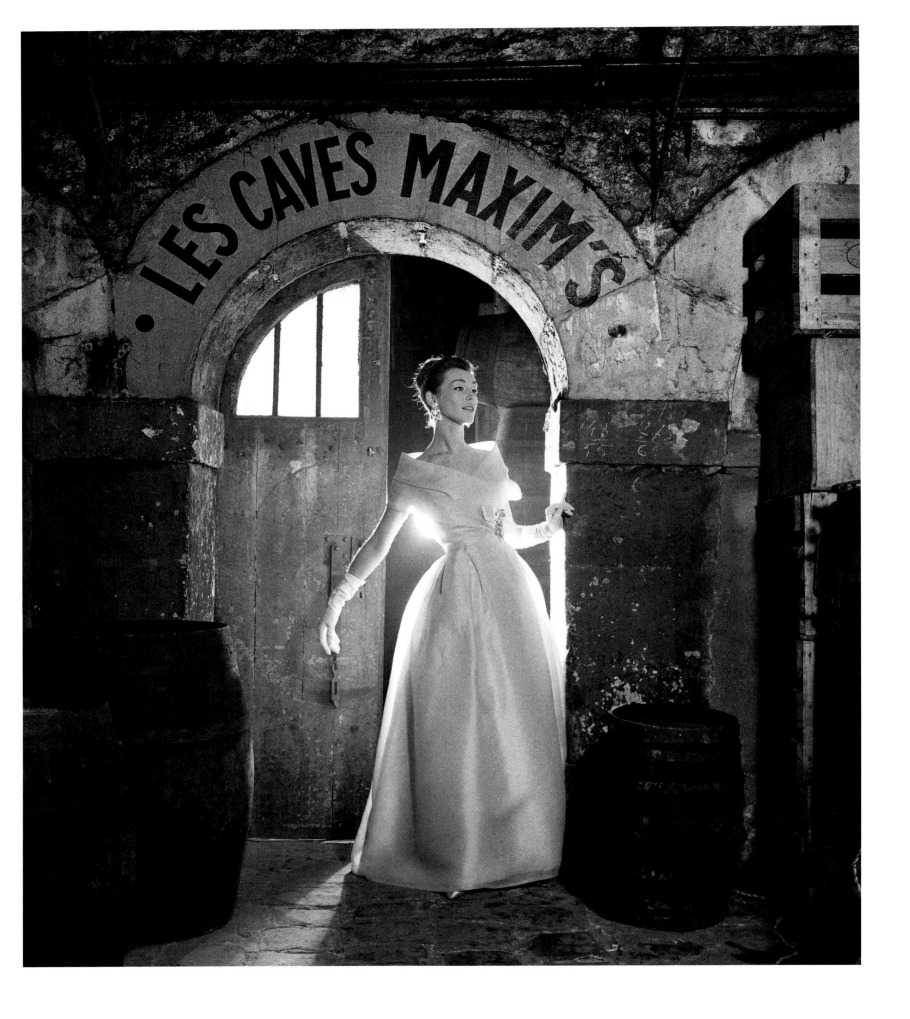

ABOVE Dior's glorious palest pink organdy satin silk gown lights up the shadows, the sash fastened by a jeweled pin to leave
a long bow down the back while the scent of Miss Dior wreathes the musty air of Maxim's wine cellars. April 1957.

FACING PAGE A wall of fine vintages in Lapérouse wine cellar offers a surreally
graphical background to Lanvin-Castillo's lightweight satin DuPont Orlon orange
evening cloak, worn over a Paris dress, April 1957.

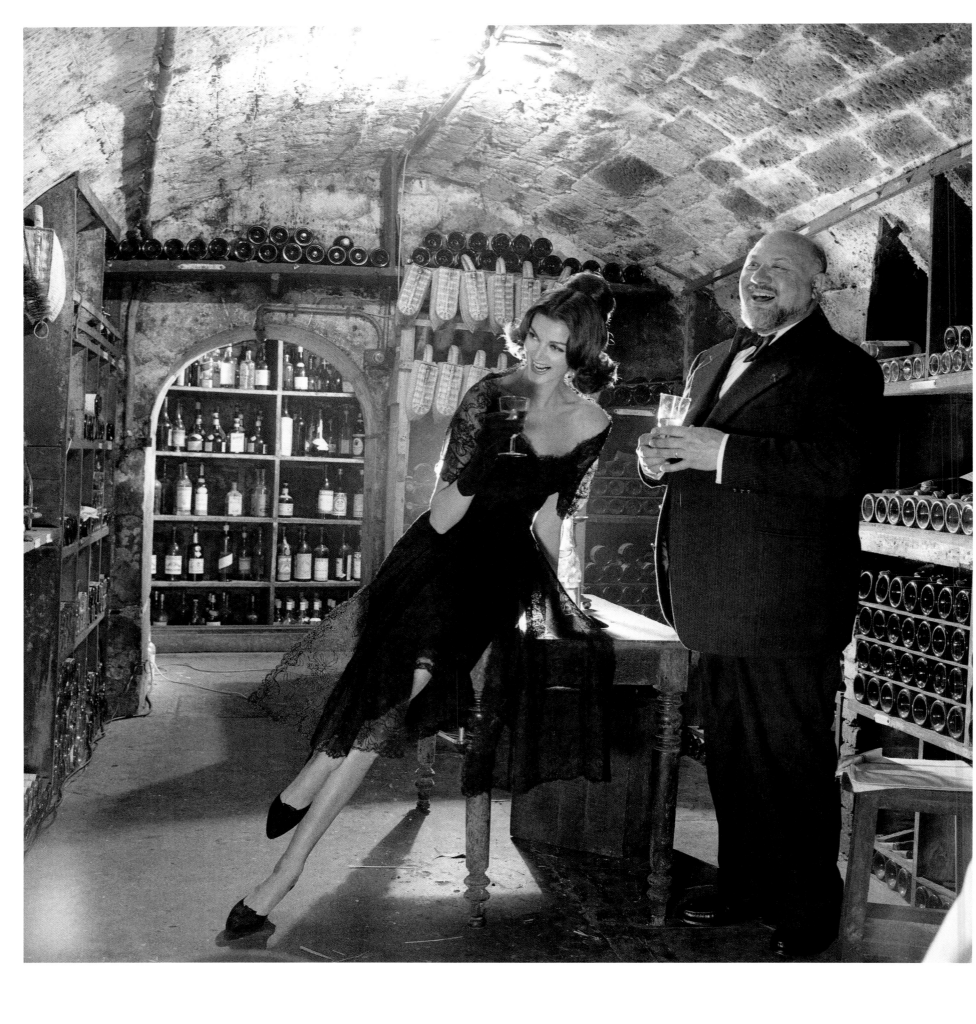

FACING PAGE In a stunning image that was never printed—though the beautiful Dessès black lace
dress from Marescot was published in another photograph, modeled by Ruth in front of the Maxim's
champagne racks—Carmen works her charm on the sommelier at Maxim's.

BELOW The Pied de Cochon restaurant in Les Halles famously never closed, just as this enthusiastic butcher never
gave up trying to get in the frame. At first he would be in the background, just peeking his head into the shot,
until Gleb finally asked him in French, "you're either in or out, which is it?" Clearly, that was all the invitation
he needed! This sumptuous dress in sky-blue DuPont Orlon satin is by Patou, with jewelry by Vendôme,
while the fragrance is Patou's Moment Suprême, April 1957.

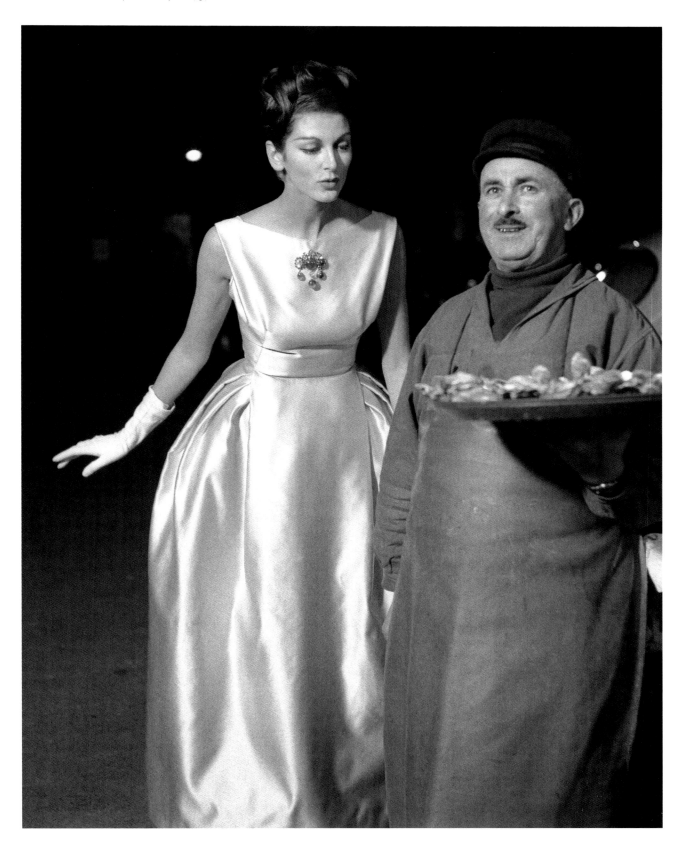

|his moment at the Pied de Cochon restaurant in the old market at Les Halles captures all the joy of that long-ago springtime, when Carmen, Ruth, and Gleb had such fun working together.

BELOW Carmen "Balmain's dotted organdy pin wheel skirt, belted in grosgrain beneath a bodice of chalk white guipure lace from Brivet, swung low in back. Petillault organdy, black and white. Hattie Carnegie. Balmain's Jolie Madame perfume." Taken at the Pied de Cochon restaurant in Les Halles, this shot was not the only one to feature the enthusiastic butcher and his tray (see p. 87), April 1957.

FACING PAGE Ruth wears a Grès grey-green dress with round neck and slightly raised waistline with matching sash on gray-green satin from Bicol, with gloves by Kislev.

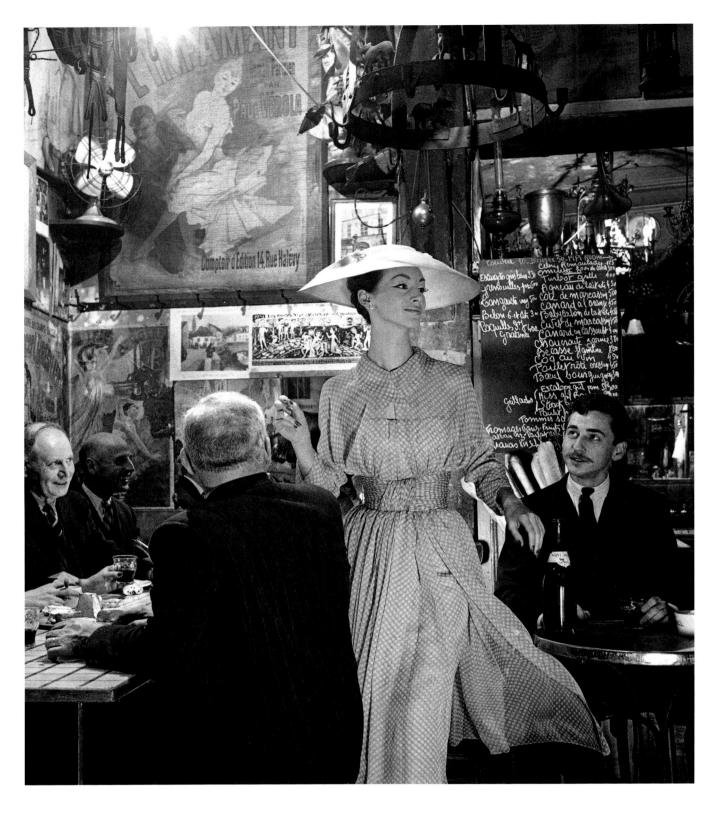

ABOVE Ruth glides between tables in a Lanvin-Castillo creation of Ducharne chiffon in beige with white polka dots, wrapped at the waist with a folded obi sash. A large straw saucer hat by Legroux Soeurs and a haze of Arpège by Lanvin finish off this graceful ensemble.

FACING PAGE Carmen at the Roger la Grenouille restaurant in a narrow-cut Dior dress with a deep pleat up one side, black silk and wool with lustrous alpaca by Staron, and topped off with a Dior black organdy hat, April 1957.

FACING PAGE Gleb was a master of night shots. He also had a creative way of showing off a dress to its best advantage by using masking tape or a safety pin and thread—little tricks that could afterward be removed by retouching in the darkroom. Polka dot dress in turquoise silk with a mermaid train by Balmain, worn with Perugia shoes for I. Miller.

ABOVE Notre-Dame, the Seine by night, and Carmen, in a pale pink chiffon dress by Griffe, March 1957.

Gleb perched on a roof in Thailand, photographed by his beloved right-hand man Minoru Ooka.

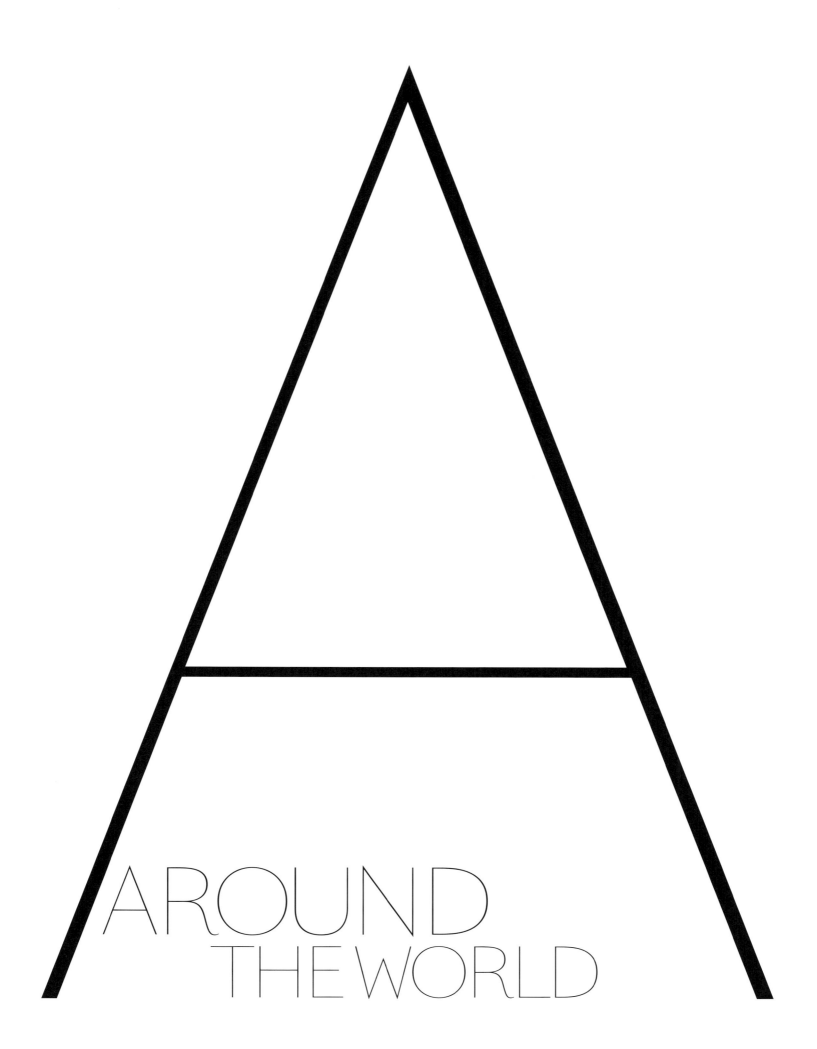

AROUND
THE WORLD

t was to be the start of a monumental year for Gleb when, in August 1957 *Harper's Bazaar* comissioned him for a photographic trip "Around the World" instiagated by Boeing to celebrate the inaugural flight of the 707—(which wouldn't actually launch until nearly a year later in 1958). This assignment would be the first and last of its kind. Traveling to eleven countries in twenty-five days, a little like a latterday Phileas Fogg in *Around the World in Eighty Days*, Gleb took his model and wife Ruth along with him on this journey of a lifetime. It would take several months to prepare in order to publish the editorial for January 1958.

The first stop would be Nara Park in Japan, then on to capture sunset in Victoria Harbor and Kowloon, Hong Kong; sunrise at the Temple of Dawn in Bangkok and the Garden of Buddhas in Ayutthaya in Thailand; a day at the beach in Ceylon (now Sri Lanka); Delhi and Jaipur in India; and the Temple of Poseidon outside Athens, Greece; finishing off with a flamenco serenade at Las Cuevas de Luis Candelas restaurant in Madrid, Spain.

This editorial introduced the new concept of "Stop Over Fashions for the New World Traveler," in conjunction with TWA and Northwest Airlines. For the cover article, "Traveling by Jet, Fashion on a New Plane," *Harper's Bazaar* editors Carmel Snow and Diana Vreeland sent fashion assistant editor Bruce Clerke and photographer's assistant Minoru Ooka—Gleb's right-hand man—along for the ride. The team traveled with nineteen pieces of luggage packed with thirty dresses, a dozen pairs each of shoes and gloves, seven pairs of sunglasses, and a panoply of cosmetics and hairspray. In the age of the internet, it is almost impossible to imagine the convolutions of booking a trip like this nearly sixty years ago. Bruce would be in charge of tickets, passports, vaccination certificates, fifty dollar bills for tipping along the way, and—naturally—a St. Christopher medallion to speed them on their way. They would have just forty-eight hours or less in each location to get the shot they needed.

FACING PAGE Cover shot would be considered the dress of '58. A cutting edge fashion prototype—just flown in from Paris under the David Crystal label—and a neat pun ("Fashion on a New Plane") celebrate the dawn of the jet age.

Harper's BAZAAR

January 1958

Traveling by Jet

Fashion on a New Plane

60 cents

TODAY'S CLOTHES, TOMORROW'S PLANE

Ruth on the runway at Boeing Field, Seattle: the first prototype of the revolutionary new Boeing 707 makes a sleek backdrop to a black and beige embroidered Irish linen suit, the jacket over a silk blouse by Pat Premo from California.

BRUCE
CLERKE
REMEMBERS...

Gleb always said that if you wanted the whole story you had to get it straight from the horse's mouth. At the suggestion of Barbara Slifka, also an assistant fashion editor at *Harper's Bazaar* and a lifelong family friend, I decided to see if I could track down the editor who traveled with my parents on their Around the World trip. To my astonishment, I managed to find her quite quickly and called her immediately.

Who would have guessed that Bruce was a woman? And when she answers the phone I know instantly that this is a woman with style. Introducing myself as Andrea, Gleb Derujinsky's daughter, I experience ninety minutes of pure delight in conversation with a woman who seems to channel both Gleb and Ruth.

Bruce couldn't remember exactly who came up with the out-landish idea for the Around the World feature, but the hope had been that Richard Avedon would be the photographer. But Avedon wasn't going anywhere. He had his studio and his clients, and a trip like that was not going to be on his dance card. No way! A trip with so little time between locations was a disaster in the making. You needed to be able to think on your feet. No photographer wants to leave a location without knowing if they have the shot they need. Every shot needed to be there on film before moving on. It was a huge risk. Alexey Brodovitch, art director at *Harper's Bazaar*, selected Gleb for this assignment in the knowledge that he was fearless and would try anything: if anyone could turn out some interesting photos it would be Gleb and his team. For Gleb, choosing his new bride and model Ruth Neumann-Derujinsky for the team went without saying, and he knew that Bruce Clerke and Minoru Ooka would complement them perfectly.

Their first task was to make a selection from the clothes approved by Diana Vreeland. All the clothes needed to travel well, so they gave preference to materials that did not wrinkle too much, such as sharkskin, Arnel crepe and Decron, silk, chif-fon, and wool. And the labels had to be American. Then every-thing was pressed and rolled in tissue paper (rolling being the best way to pack clothes, as anyone who has been in the army, as Gleb had been, will tell you) for the long trip. It was like preparing for a vacation, but fifty times worse. Nowadays, if you forget something you can usually replace it at your destination. In September 1957 this was far from the case. Everything had to be planned in advance. My mother left a handwritten note saying, "Luck is when Preparation meets Opportunity." How right she was.

The first leg was from New York to Seattle, where Gleb shot in front of the very first 707 prototype on the airstrip at Boeing Field. He must have been fascinated by these huge birds, their engineers, and their pilots. This was not just any jet but firstclass travel in the skies, complete with all the luxuries: fine china, silverware and crystal glasses. It would be nearly a year from September 1957 to the actual launch flight by Pan American World Airways of the Boeing 707-121.

The months of preparation for this incredible journey were a testing time, and there were plenty of naysayers. But this was not going to be a tourist trip, and Gleb was uncompromising in his pursuit of the right concept and the right images, as Bruce remembers:

"Avedon shot dresses and clothes, Gleb shot women living in them. Gleb had a determination to have it his way, not the client's way, or the editor's. What he saw and photographed was what he thought it should look like. He wasn't appreciated for this character trait, as he didn't kowtow to others' whims. Gleb would most likely not win most popular. He just didn't fit in".

The itinerary of the trip was relentless: the first stop was Japan, followed by Hong Kong, Thailand, Ceylon (Sri Lanka), Delhi, Jaipur, Athens, and finally Madrid. Making a success of it meant scouting for locations as soon as they landed and arranging hires, such as elephants that failed to turn up in Thailand. In tropical climes like the Thai jungle they had to cope with endless problems, such as tissue paper disintegrating into the clothes or wrinkled dresses: on one occasion a guide vanished into the jungle and somehow returned with an immaculately pressed dress. In India all their luggage disappeared, only to be miraculously returned by frail porters, while in Greece Ruth had to be anchored to the ground by invisible tie downs as tempestuous winds raged around the Temple of Poseidon on its exposed promontory. With forty-eight hours per stopover, solutions had to be found! As Bruce recalls, "Gleb wasn't pleasant in the studio, but out in the world he was in his element, and unstoppable."

Ruth, meanwhile, was the dream model. If Gleb said she had to stand in some seemingly impossible position, then stand she would. She never refused anything—though if a snake-charmer appeared she would be off like a shot, dragging her long chiffon skirts behind her. She would be in full make up from first thing in the morning, and wherever they went people would wonder who they were and what they were doing. When they said they were doing a fashion shoot for *Harper's Bazaar* all doors opened for them, and they became the stars of their very own living, breathing movie.

NARA DEER PARK, JAPAN

The deer grazing under the thousand-year-old sacred trees in Nara Park, in the Japanese town of Nara, seem untroubled by the equally graceful presence of Ruth in a simple beige chiffon dress by Carlye. The parasol was to be as ubiquitous a feature on this shoot as the low-heeled Capezio shoes and pleated skirts.

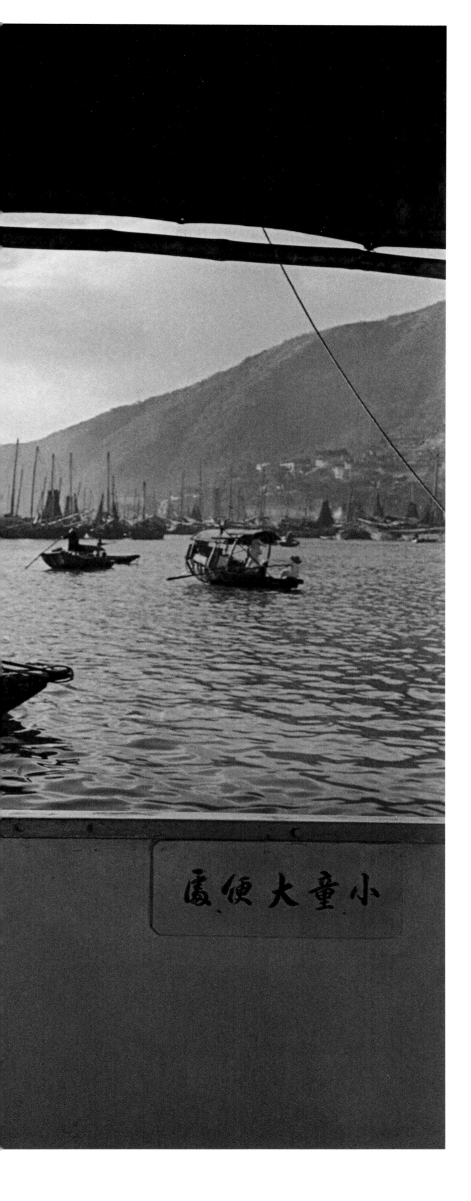

HONG KONG HARBOR

A lavender silky cotton Jane Derby dress
in a floral print would be good for lunch anywhere
in the world, but in this floating restaurant
in Hong Kong harbor, where cast and crew
would dine, it is simply perfect.
Traveling abroad in 1958 was an adventure
in itself, and keeping a models fresh for shoots
in the overwhelming heat and humidity was
a major feat. The tissue paper used to pack the
clothes disintegrated, and the make up melted.
But Hong Kong offered many Western-style
comforts, and the food was wonderful.

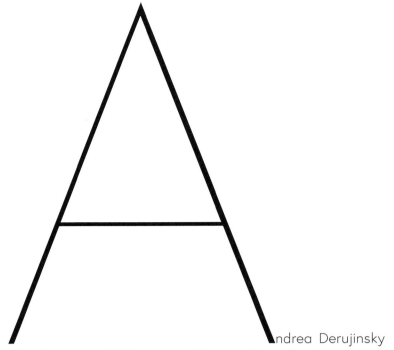

ndrea Derujinsky
asked me to tell the story of how a beautiful photograph
and an extraordinary encounter resulted in this book. Two
years ago, on a rainy mid-August holiday in Paris, I was alone
in my office, waiting for some information needed to sign off
on a printing. While feeling very sorry for myself for being the
only person in Paris at a desk that day, my eyes fixed on a
picture that I'd torn out of a magazine some months earlier
and that was pinned up over my desk. The marvelous photo-
graph by Gleb Derujinsky depicted the elegant silhouette of
a woman posing with a parasol, practically in levitation on a
junk in Victoria Harbor. For a few minutes I was transported
away from my desk and into the glamorous and exotic world
of the graceful model standing alone in this improbable set-
ting. Although the photographer's name was familiar, after
browsing through the incredible variety of fashion photos
of ethereal beauties and portraits by him on line, I realized
that no books and few articles had been published on his
work. Some research led me to a short piece written by the
New York writer and historian Michael Gross for *Bergdorf
Goodman Magazine* in 2010, and I immediately sent a mes-
sage to Michael's address. To my surprise, he answered a
few minutes later. He knew the photographer's daughter,
Andrea, and promised to put me in contact with her. For me,
and my impassioned editorial team, that rainy day in August
marked the beginning of a wonderful voyage of discovery of
Gleb Derujinsky's immense talent and his daughter Andrea's
boundless enthusiasm. By taking fashion out of the studio
and far away from our everyday existence, he invented a
unique, creative universe for every photograph, inviting us
to accompany him on poetic journeys where we fall out of
ourselves and into whole new worlds. Gleb was the travel-
ling photographer of elegance. His dreamlike images, where
the implied narrative is invariably infused with an inimitable
lightness of being, are frozen in time, yet still every bit as
fresh and modern today as they were when they were imag-
ined more than half a century ago.

SUZANNE TISE-ISORÉ

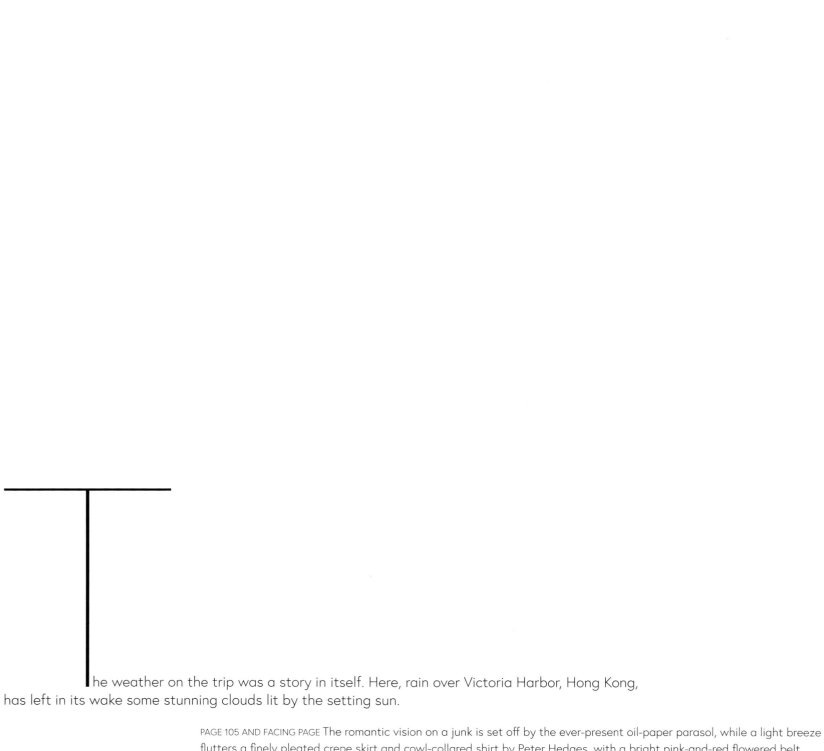

The weather on the trip was a story in itself. Here, rain over Victoria Harbor, Hong Kong, has left in its wake some stunning clouds lit by the setting sun.

PAGE 105 AND FACING PAGE The romantic vision on a junk is set off by the ever-present oil-paper parasol, while a light breeze flutters a finely pleated crepe skirt and cowl-collared shirt by Peter Hedges, with a bright pink-and-red flowered belt.

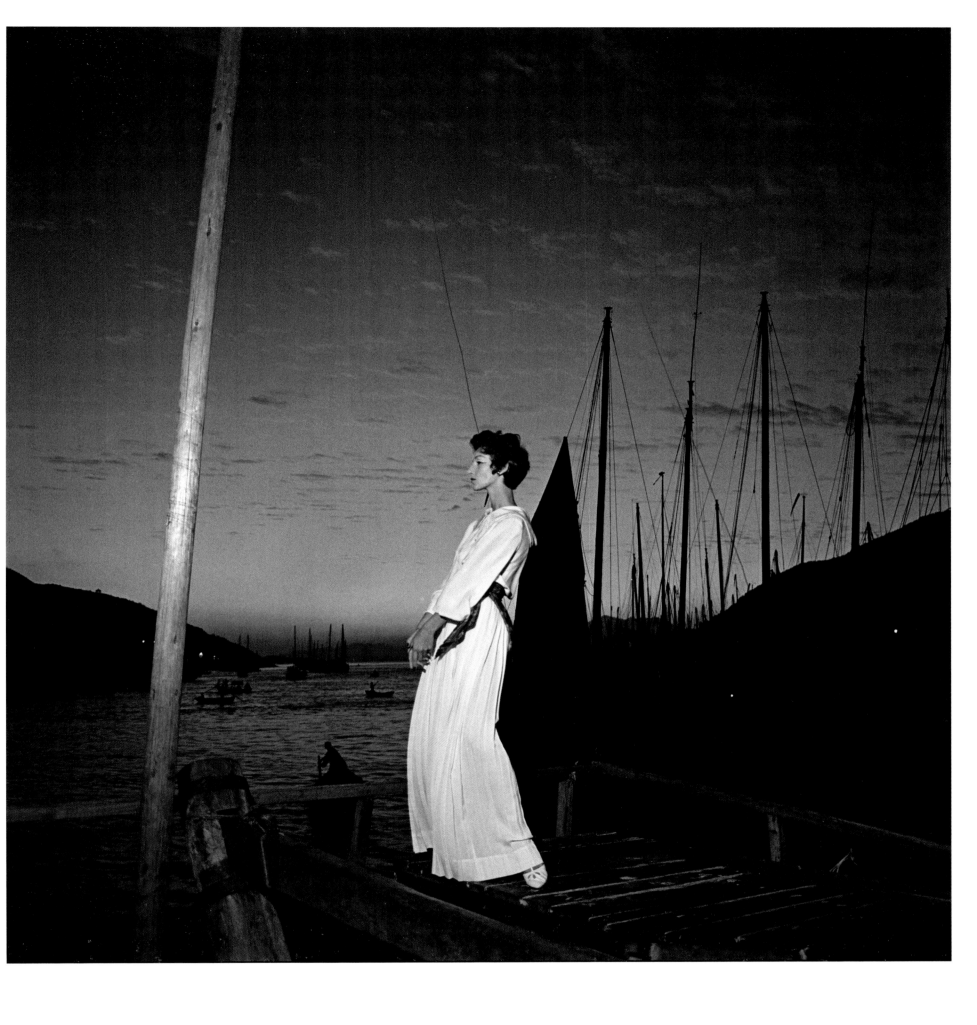

"Gleb Derujinsky's photographs evoke the best of *Harper's Bazaar*: exquisitely beautiful, original, and instantly iconic images of a very fashionable life."

—Glenda Bailey, Editor-in-Chief, *Harper's Bazaar*

TEMPLE OF DAWN, BANGKOK

Sunrise at the Temple of Dawn (Wat Arun) in Bangkok sets the stage for this beautiful white knit jersey with attached panels by Anna Miller.

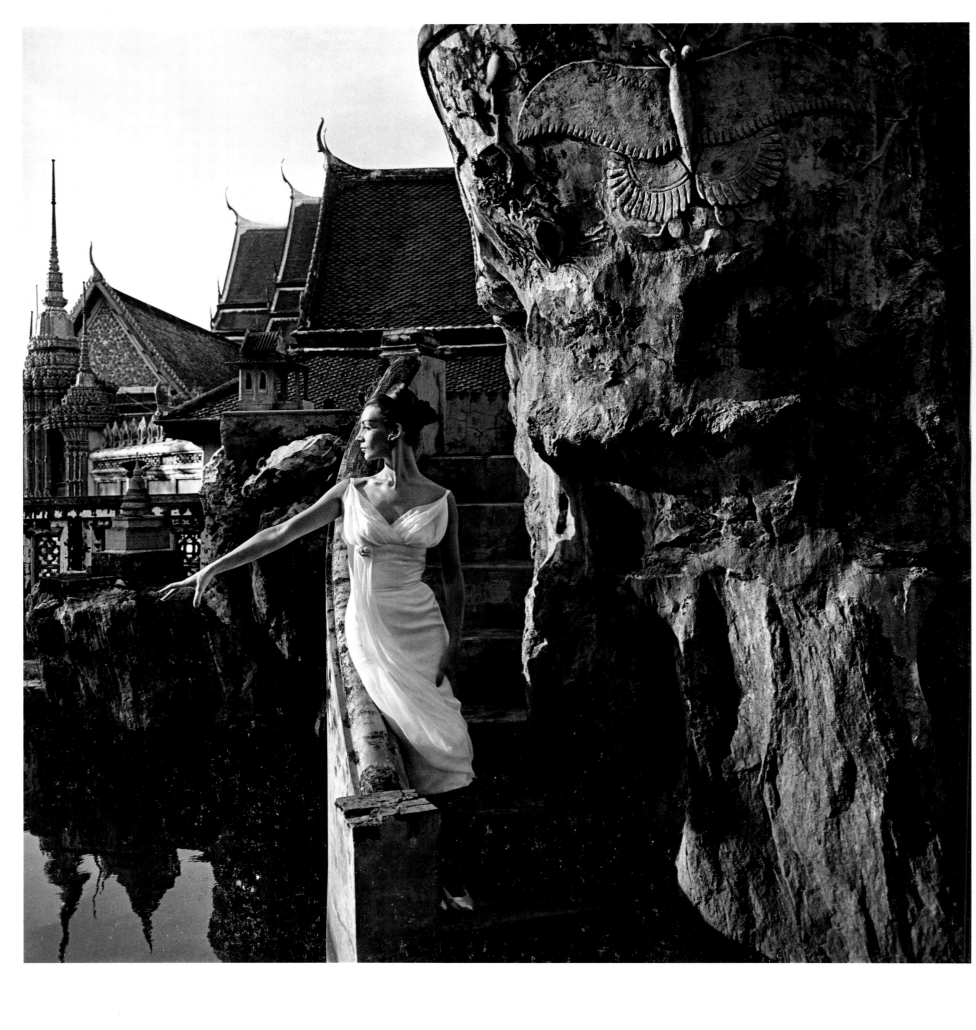

กรุงเทพมหานคร อมรรัตนโกสินทร์ มหินทรายุธยา มหาดิลก
ภพ นพรัตนราชธานีบูรีรมย์ อุดมราชนิเวศน์มหาสถาน อมร
พิมานอวตารสถิต สักกะทัตติยวิษณุกรรมประสิทธิ์

Bangkok's full name (claimed to be the world's longest place name) translates as "City of angels, great city of immortals, magnificent city of the nine gems, seat of the king, city of royal palaces, home of gods incarnate, erected by Vishvakarman at Indra's behest"; craggy rocks, ancient carvings, and intricate architecture make the perfect foil for this romantic creation.

IN THE GARDEN OF BUDDHAS

In the serene Garden of Buddhas in Ayutthaya, the ancient capital of the kingdom of Siam, Ruth models a lovely thin cotton tropical-flowered dress in deep oranges and greens, by Brigance. Gleb had booked elephants for this shoot, but they failed to show up. Perhaps the pretty parasol they found here, which was to become such an invaluable prop, was some consolation.

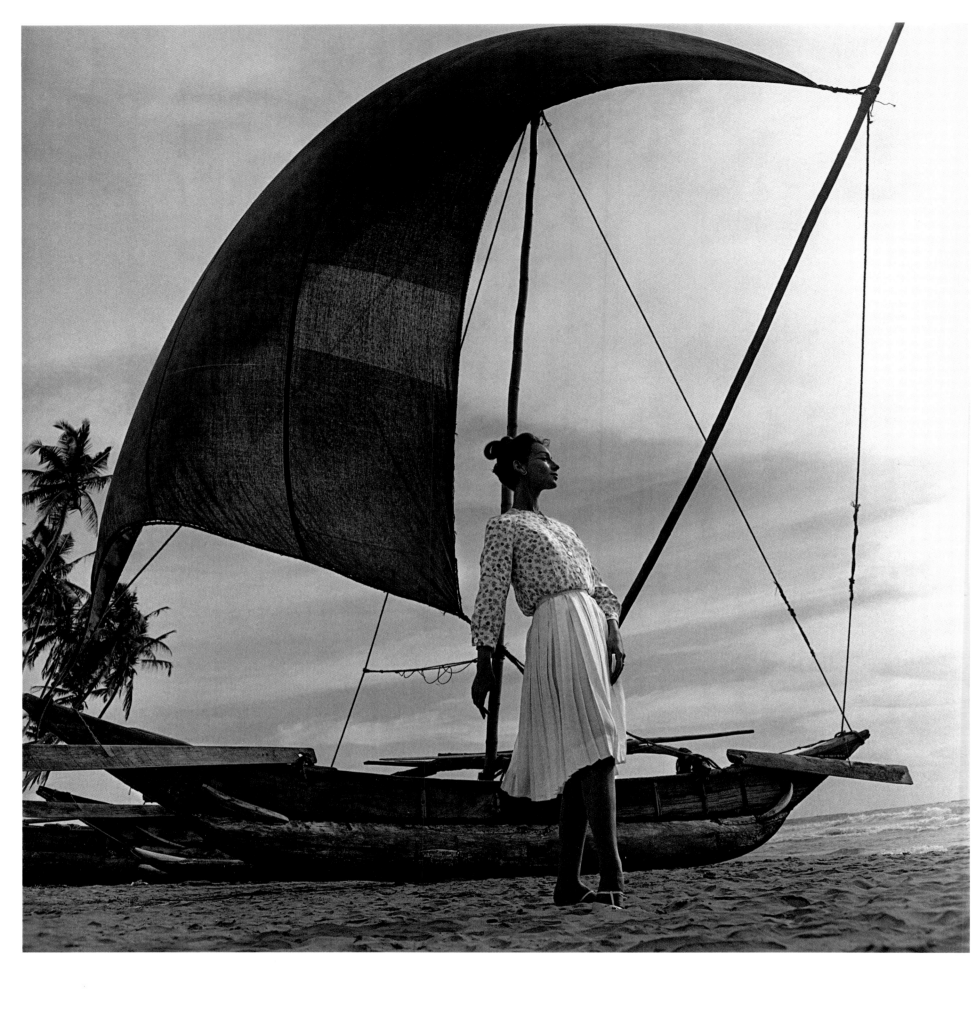

"The dress that travels with a jacket travels furthest," declared *Harper's Bazaar*.

Underneath this lovely flowered silk cardigan is an Arnel crepe sleeveless V-neck dress with a pleated skirt—one of the leitmotifs of this shoot—by Kasper. Uppuveli beach in Sri Lanka, with its catamaran fishing boats, or *oruwa*, remains as stunning now as it was then.

Textile workers stretch endless lengths of material in a grass field in front of the Jama Masjid in Delhi,
one of the largest mosques in India, with a vast courtyard capable of holding over twenty-five thousand worshippers.

In the foreground, Ruth wears a versatile pleated skirt and white bateau-necked overblouse
in Celanese Arnel flannel by Haymaker. The elaborate lanterns, meanwhile, are a key feature of
in the Hindu calendar, being used to celebrate Diwali, the "festival of lights."

The Vrihat Samrat Yantra is the largest gnomon sundial in the world, its immense size— 88.6 feet (27 meters) in diameter, with a base measuring 147.7 feet (45 meters)—enables it to measure time with extreme accuracy.

The simple white Arnel sharkskin suit separates a cardigan-style top and slim 50s pants that we would now call Capris.

THE JAIPUR OBSERVATORY

The immense stone observatory of Jantar Mantar
in Jaipur is now a popular tourist attraction, but
in 1958 it was a little-known wonder of the world.
This miracle of eighteenth-century Indian science
was a stunning choice for a photo shoot, and
enabled Gleb to give full rein to his dazzling flair
for composing a picture. Although the Parisian
engineer Louis Réard had created the bikini in 1946,
it was not to become popular until the 1960s. Ruth
poses in one of the observatory's two sundials, the
Jai Prakash Yantra, built of marble with intricate
astronomical markings that happen to echo her
geometrically patterned two-piece cotton swimsuit
with orbital designs in deep blue and azure, by
Bandini. These extraordinary hemispherical sundials
map an inverted image of the sky, measuring
altitudes, azimuths, hour angles, and declinations.
It is not surprising that a trained pilot should be
drawn to this incredible instrument, devised nearly
three hundred years ago. The other sundial, the vast
Vrihat Samrat Yantra, is topped with a platform
for predicting the arrival of monsoons—which is
ironic considering that two days later the party
would be caught up in a monsoon that had pursued
them from Thailand. Published in a tiny spot, these
remarkable shots could easily have been missed.

The magazine cover shot was taken here as
well, but no negative of this survives, nor does
another published image of Ruth modeling an Arnel
sharkskin suit by Tabak of California.

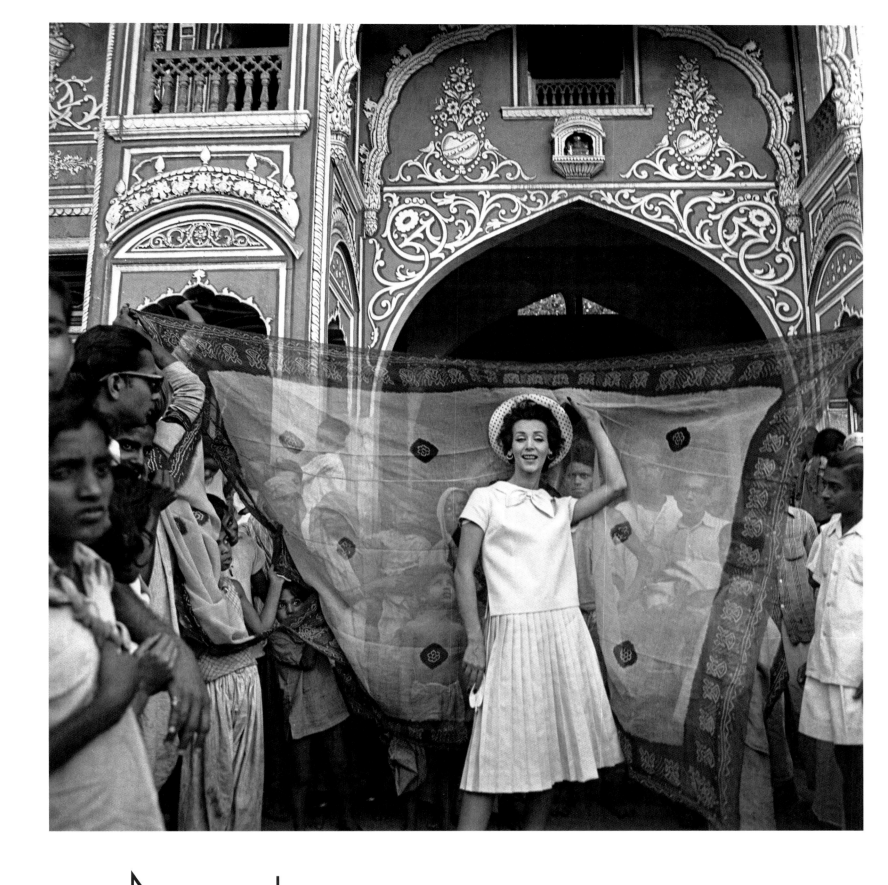

Newly dyed saris make a stunning backdrop against the glorious pink-and-white facade of the Hawa Mahal Bazaar in the "pink city" of Jaipur.

Just when you think thirty dresses should be enough, we revisit the pleated skirt—this time topped with a sky-blue cotton over blouse with a cute bow, and polka dot hat by Emme.

There is no surviving negative for this striking photograph taken at the Temple of Poseidon, perched on the plunging cliffs of Cape Sounion, south of Athens. A 2 ¼ x 2 ¼ from the contact sheet is all that remains of this magical moment, where Ruth (who happened to be battling Asian flu) helped with the lighting by holding aloft an Olympic torch—in fact a broomstick with a shower nozzle soaked in diesel, which created a flame guaranteed to withstand 35 mph winds. Gleb lit the resulting scene with car headlights. Ruth wears the same dress as in the published shot taken at the Temple of Dawn in Bangkok.

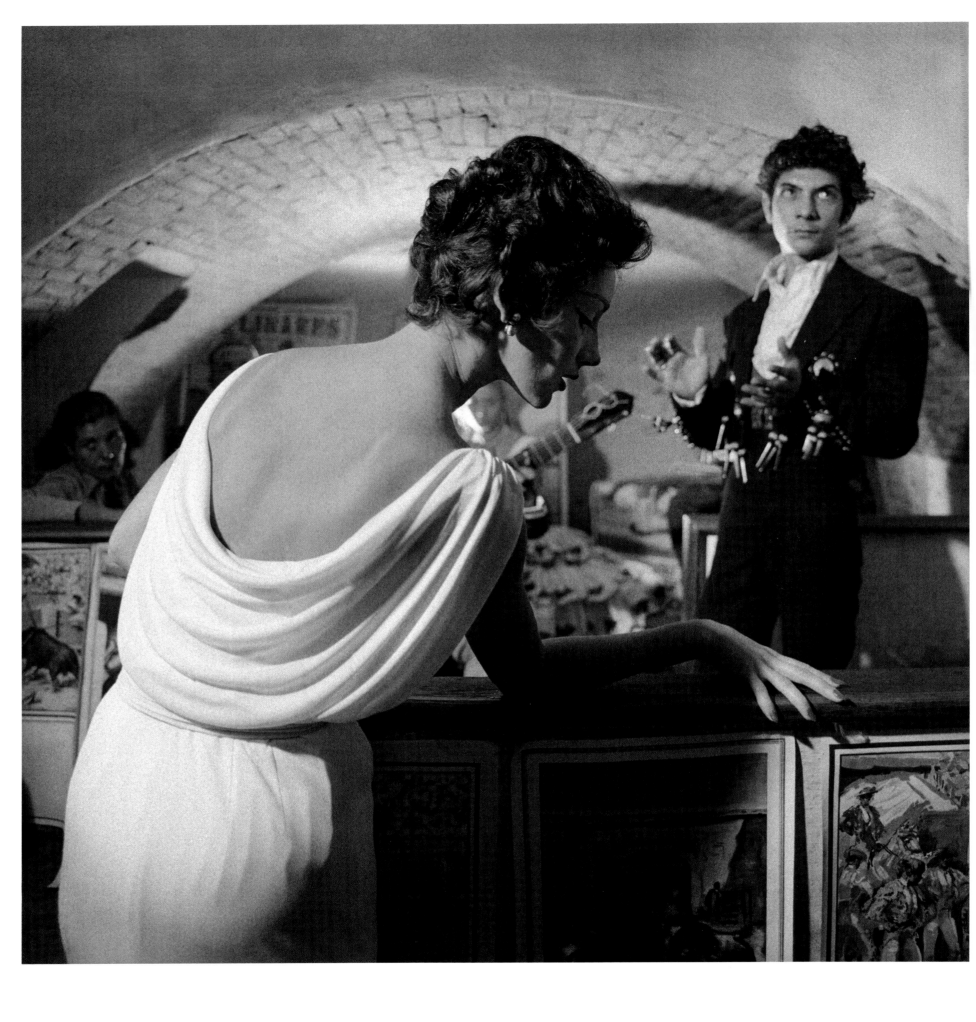

The new jetsetters needed clothes designed to look great right out of their suitcase, but were not prepared to sacrifice style for comfort. This short dinner dress in white matt jersey by Jonny Herbert would be ideal for an evening of flamenco at Las Cuevas de Luis Candelas, a former brigands' hideout in Madrid. For this shoot, a group of gypsies had been hired to fill the restaurant with local color. Instead of coming in traditional gypsy dress, however, they arrived in Balenciaga-type street clothes, having, as Bruce remembers, "borrowed clothes from friends and neighbors. Not exactly what they had in mind!"

"Gleb Derujinsky is an original, the Indiana Jones of fashion photographers. He flew his own private plane to exotic places—models and editors in tow."

—Melvin Sokolsky, photographer

Ruth wears a Maxwell dress in white linen-like silk, caught in at the waist
with a beige suede belt, and complemented by T-strap Capezios, a white leather Breton by Emme, and a loose
oatmeal tweed coat by Harmay over her arm, ready for a stroll in the cool of the evening.
On the photographer's stand, we can see Gleb's pictures of Ruth.

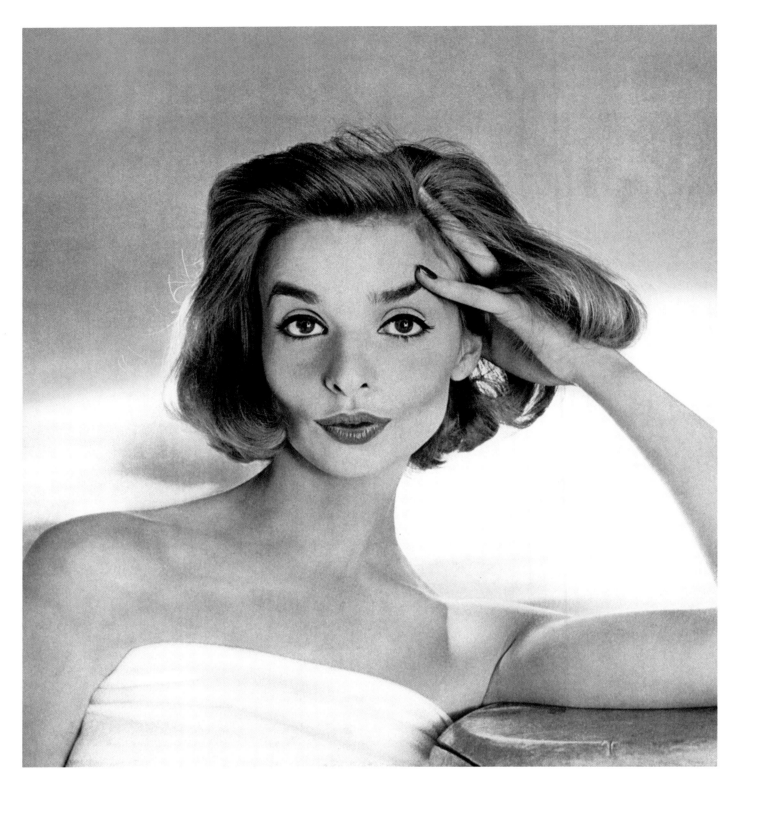

HAUTE
COUTURE
AND
TIMELESS
STYLE

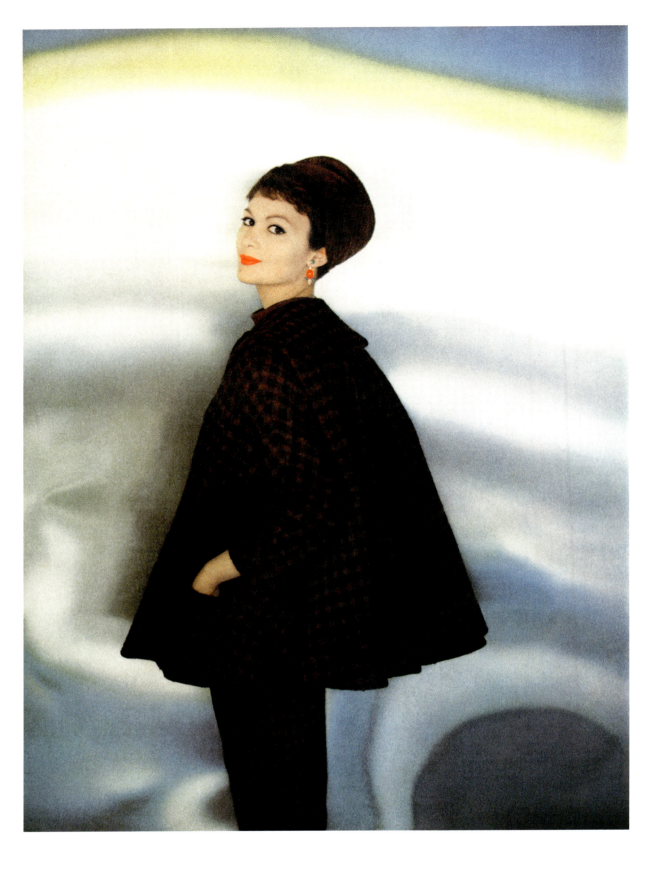

ABOVE In this rare studio shot, the swirling blue cellophane of the backdrop echoes his gallery shoots. Silhouetted against it, Isabella Albianco wears a short coat, a John-Frederics nutria fez, ruby earrings by Hattie Carnegie, and Elizabeth Arden clear red lipstick.

FACING PAGE A panoply of accessories, clockwise from left: brown panne velvet pump with a rhinestone buckled belt across the instep by Peter de Liso; Roman-striped scarf in polished taffeta by Glentex; Bally "brass" satin pump with a neat bow; periwinkle lambskin glove by Kislav; Bienen-Davis slender alligator satchel; rainbow rose-cut jewels and calf skin belt; Hattie Carnegie emerald cabochon necklace, September 1957.

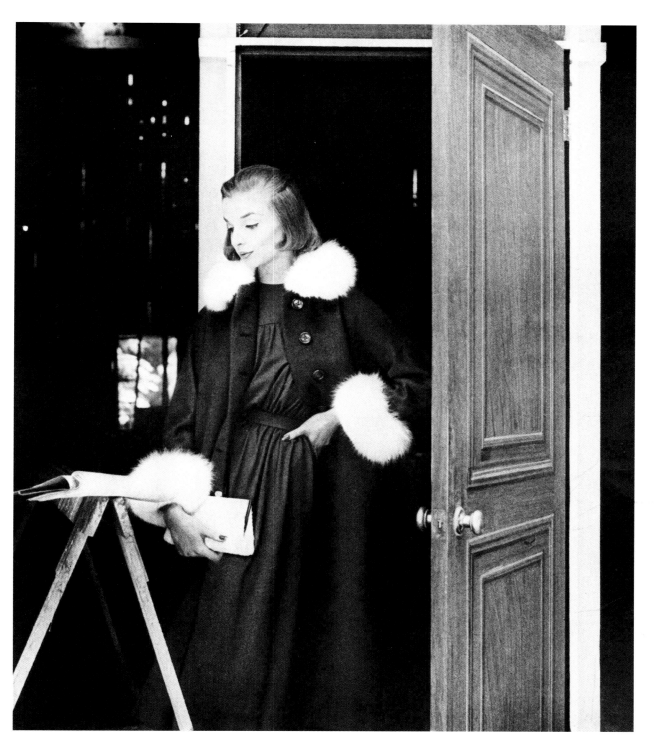

FACING PAGE Iris Bianchi strikes a relaxed pose in a Dani Junior Flame red jersey coat,
cropped at the knee to show stylish Glen of Michigan houndstooth wool tapered pants
with Town and Country shoes. Gilded Star Pin by Castlecliff.

ABOVE Iris wears a red worsted jersey dress by Heller and a red wool coat with collar
and cuffs in white-dyed fox by Anne Fogarty. Fur bag by Winter, September 1957.

IRIS BIANCHI REMEMBERS...

Of all of the photos of my career as a model—I worked with Avedon, Hiro, Scavullo, Bob Richardson, Sokolsky, Diane Arbus, Saul Leiter, James Moore, and many others—this photo taken by Gleb Derujinsky is and has always been my favorite! I first met Gleb when he photographed me in Paris, and subsequently continued to work with him and got to know him and Ruth personally. Gleb and Ruth were both very talented, good-natured people who became good friends—that I loved and miss. I was very fortunate to have had them as such a part of my life.

B

ringing Up Baby was one of Gleb's favorite movies. Here—against a New York backdrop featuring the Art Deco lines of 20 Exchange Place—he sets up a little parody on it, with Bobby Said's cheetah playing with the model. The wooden sculpture of Rabindranath Tagore, the first non-European to win the Nobel Prize in literature in 1913, was done from life in 1927. Carved from lignum vitae, the densest of woods, it is a tribute to Gleb W. Derujinsky, artist and Gleb Jr.'s father.

BELOW A gray and lilac glen plaid wool suit by Talmack is the new feminine, blue bowler by I. Magnin.
FACING PAGE Carmen wearing a Lilli Ann suit in creamy linen-like rayon, Hattie Carnegie straw hat, and Castlecliff clip earrings, February 1958.

"When writing college recommendations for students, one is often asked to list the first five or six adjectives that occur to one. With Gleb they would be: charismatic, talented, enthusiastic, intuitive, energy-filled, individualistic, and iconoclastic, all to the nth degree. We all felt very much the richer for being in his presence."

—George Moffat, sailplane pilot, Gleb's lifelong friend

FACING PAGE It was not unusual for American designers to be inspired by Chanel designs, like this suit by Davidow. The matching hat seals the deal, in a shot taken in front of the Webb & Knapp Building at 383 Madison Avenue, February 1958.

Beauty spots: gray polka dots in natural Shantung by Balenciaga, May 1958.

Back in the studio in NYC, Gleb shoots Simone D'Aillencourt again—having met her in Paris
two months earlier—in a Givenchy deep beige wool coat, May 1958.

Immaculate tailoring in a silk blouse by Emilio Pucci, July 1958.

Dramatic cape coat in ruby-red silk faille lined in shimmering white satin,
made to order by Fontana, June 1958.

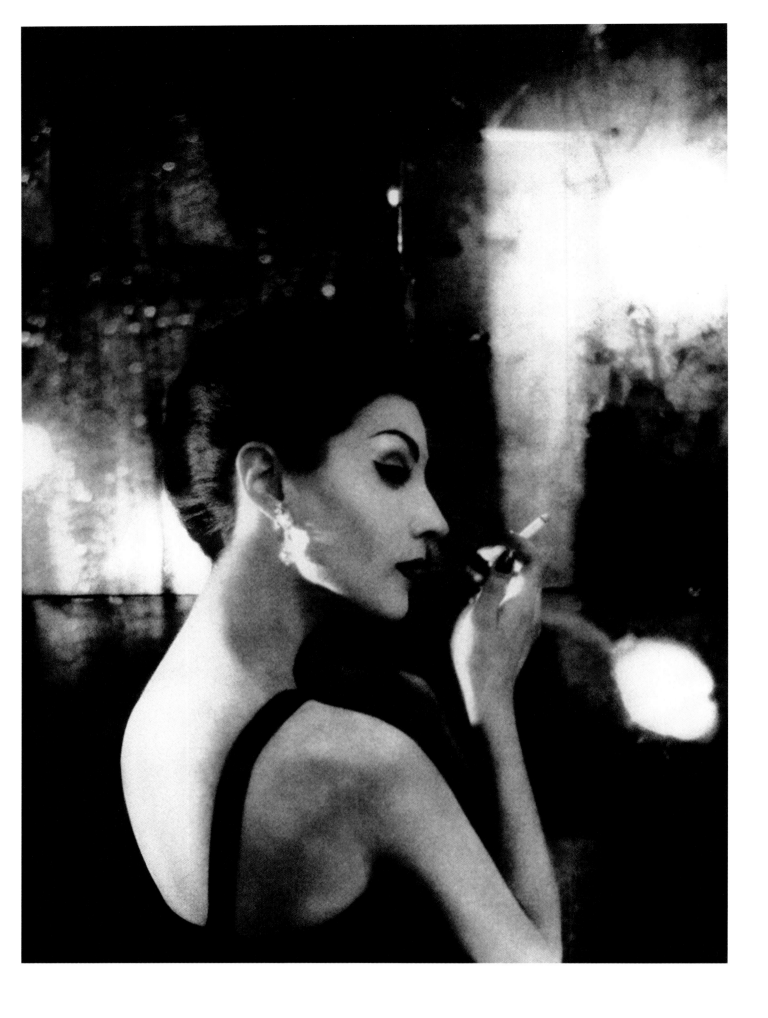

ABOVE Ruth is beguiling with her immaculately upswept French twist, designed to show off her graceful neck and Tiffany diamond earrings. Coiffure by Berthold.

FACING PAGE Carmen in the chandelier shop: Nesle Inc., a family business that opened in Manhattan in the mid-1930s and now trades in Long Island City in Queens, is one of those unique destinations with the personal touch that drew Gleb like a magnet. The lovely dinner dress in golden-flowered white silk satin, with little bows to fasten on the sides, is by Mollie Parnis, October 1958.

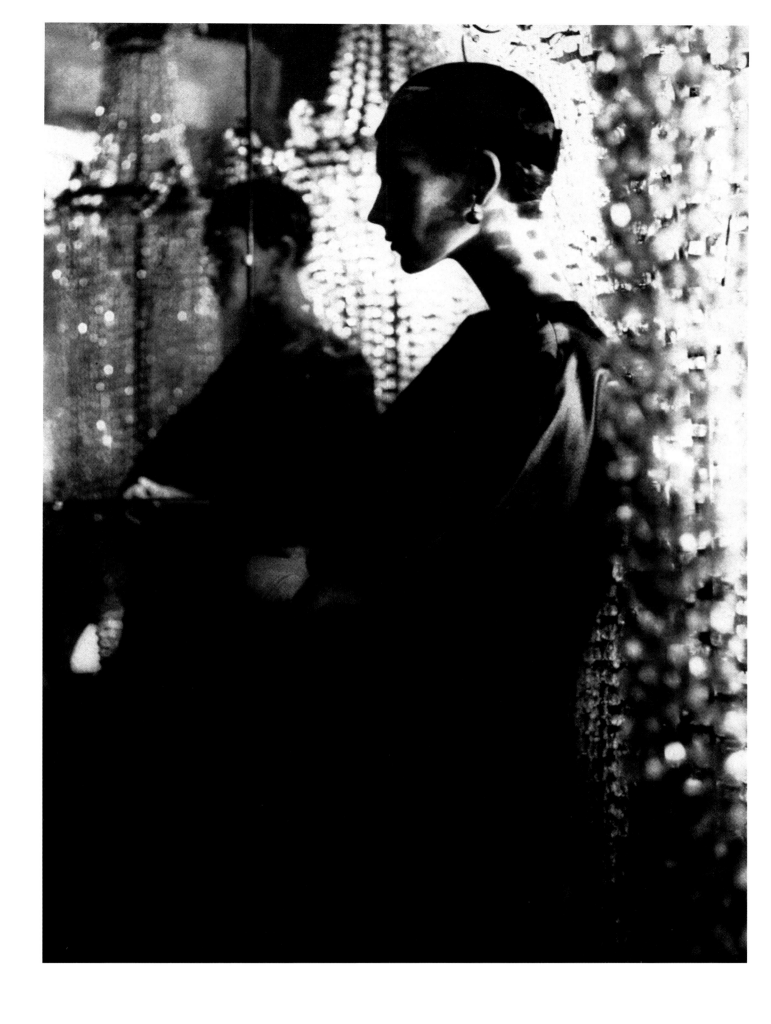

FACING PAGE Fashion becomes fantasy in a transparent lace coat with a pouf in the same taffeta
as the dress worn underneath it, by Anita Modes.

ABOVE Crystal and mirrors add shimmer and sparkle to the drama of a Dior
of New York velvet-lined black satin coat over a two-piece black satin dress,
with a black velour hat banded in satin. October 1958.

BELOW A cozy studio shot of Ruth in a snow-white, deep-pile Ascher wool coat by George Carmel. Earrings by Richelieu, shoes by I. Miller, and gloves by Wear Right complete the ensemble.

FACING PAGE Tri-Pod coat by Originala, the exclusive New York suit and coat house founded in 1941 by the Bader Brothers, February 1959.

"The question of 'What happened to the originals?'… can, at times, become a mystery…. Some photographers, such as Hiro and Richard Avedon, have kept negatives of every picture they've ever taken. Another photographer, on the other hand, a man whose work appeared prominently in *Bazaar* for at least ten years, one day dumped all his original artwork in a warehouse in New Jersey and moved out west to fly sailplanes and write novels…. Needless to say, there are no Gleb Derujinsky negatives, today, to be found anywhere."

—Anthony T. Mazzola, former Editor-in-Chief of *Harper's Bazaar,* in *125 Great Moments of Harper's Bazaar*

There is a lot of truth in this story. But we should never forget that artists can be very temperamental, especially if they feel underappreciated. Gleb himself would not come to truly appreciate his work until he was in his seventies, and he kept only a few negatives.

FACING PAGE Peeking through the white Venetian lace and under the hem of this sheer cotton chasuble is a black form-fitting wool bodice by Traina Norell. Hat by Emme, shoes by I. Miller, March 1959.

This image of Ruth in a Larry Aldrich silk tussah dress and Walter Florell organdy hat has all the
hallmarks of a tribute to Horst P. Horst, one of Gleb's favorite photographers, April 1959.

Ruth in a graphic green-and-yellow striped Staron silk dress by Galanos, with a leafy green hat
by Mr. Arnold and Nettie Rosenstein earrings, April 1959.

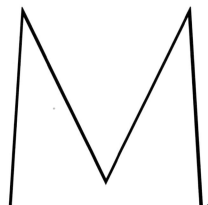any famous boxers trained here, including Jack Dempsey, Georges Carpentier, Primo Carnera, Fred Apostoli, Joe Louis, Rocky Marciano, and Sugar Ray Robinson. Gleb took this photo just before the gym finally closed.

FACING PAGE Baroque black velvet evening coat by Sarmi, with encrusted embroidery and Russian sable collar, shot at Stillman's Gym in New York City, owned by the legendary boxing trainer Louis Ingber, aka Lou Stillman, October 1959.

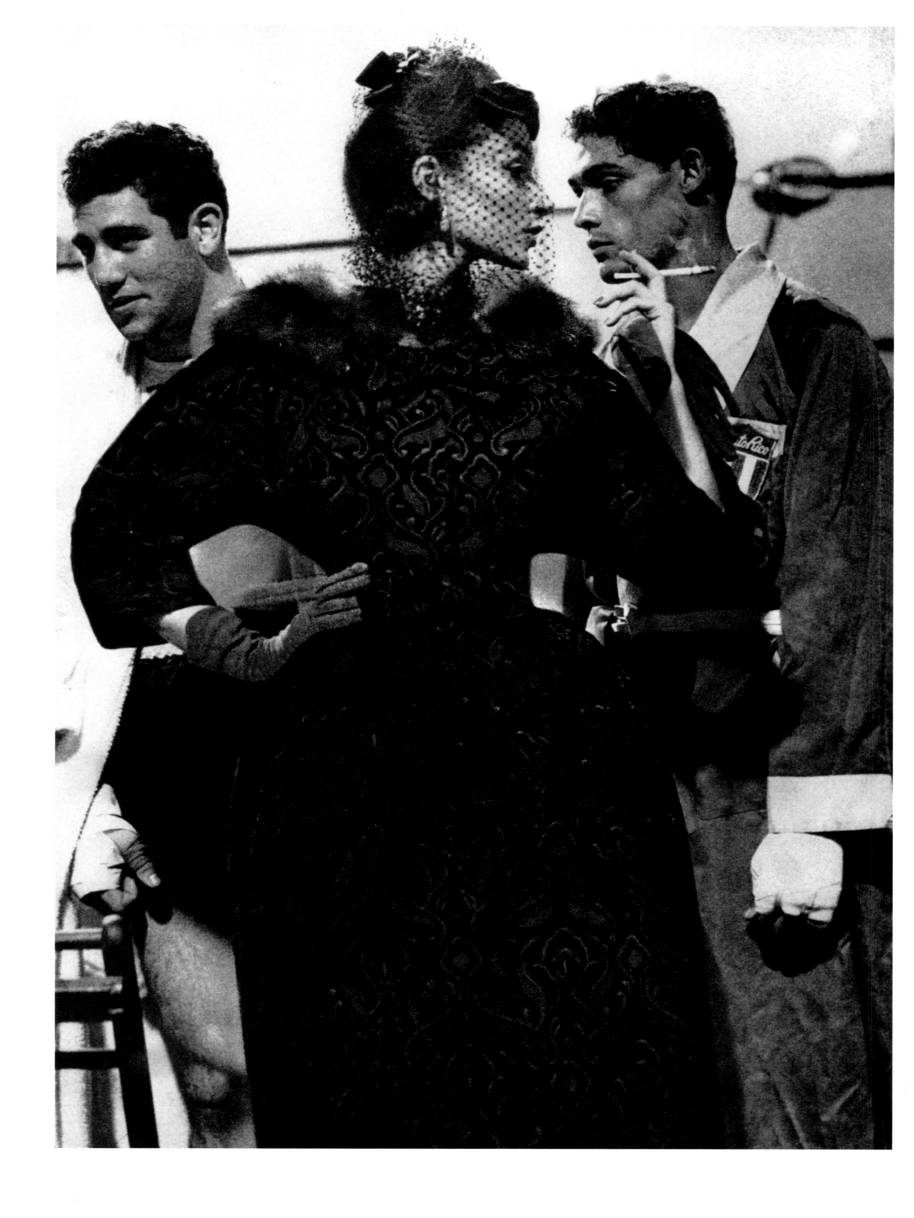

"His work had the look
of a painter, as if you were
doing a canvas."

—Barbara Slifka, Assistant Fashion Editor, *Harper's Bazaar*

FACING PAGE A breathtaking Nina Ricci dress in red organdy banded by white
cotton organdy, made to order at Elizabeth Arden, with Victory Red Elizabeth Arden
lipstick and Judith McCann earrings, June 1960.

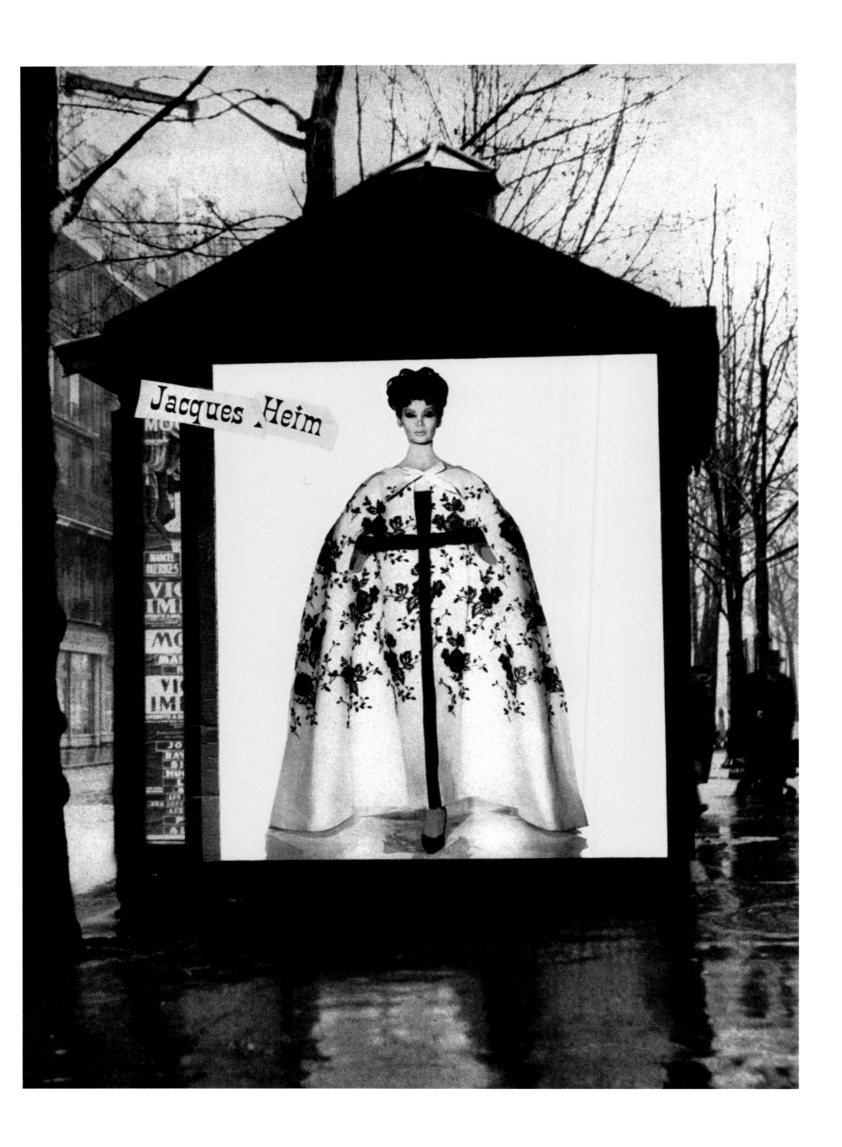

Jacques Heim

G

leb had visited Paris in the springtime since 1952, shooting the finest of the Paris collections and adding new locations to his street-styled shots, with the scenes from everyday life in the city that added so much to these directed but authentic images. He was already notorious for asking his models to climb to great heights for his billboard images, but in March 1961 he introduced a new concept, taking studio shots and posting them on walls throughout Paris—to wonderfully fresh and striking effect.

Capucci embraces Aphrodite in a black lace dress and crowns her in pouffed white organdy, April 1961.

Fabiani's frilly egg-shaped white silk organdy skirt is topped with a black velvet strappy top, April 1961.

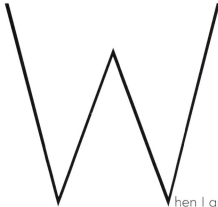

W hen I asked Nena von Schlebrügge to recall her meeting with Gleb over fifty years ago and tell me about her trip to Turkey (see p. 213), she revealed that she first met Derujinsky and worked with model Ruth Derujinsky a month earlier, in December 1961. This shoot was an excellent opportunity for them to get to know each other's way of working and to decide if the trip to Turkey would work—as the fantastic images they produced as a team certainly suggest.

BELOW, LEFT For entertaining at home, the best-dressed hostess has fun with new looks such as this light satin shantung tunic and chic bellbottomed slacks in the fairest pink color by Irene Galitzine. Coiffures for both shots by Mr. Monti, December 1961.
BELOW, RIGHT Nena wears an effortless evening tunic and slim fringed pants in brilliant peacock blue by Irene Galitzine.

FACING PAGE Pierre Balmain's intricate gold and coral beaded top is dazzling above a flowing white chiffon skirt by Véron, April 1961.

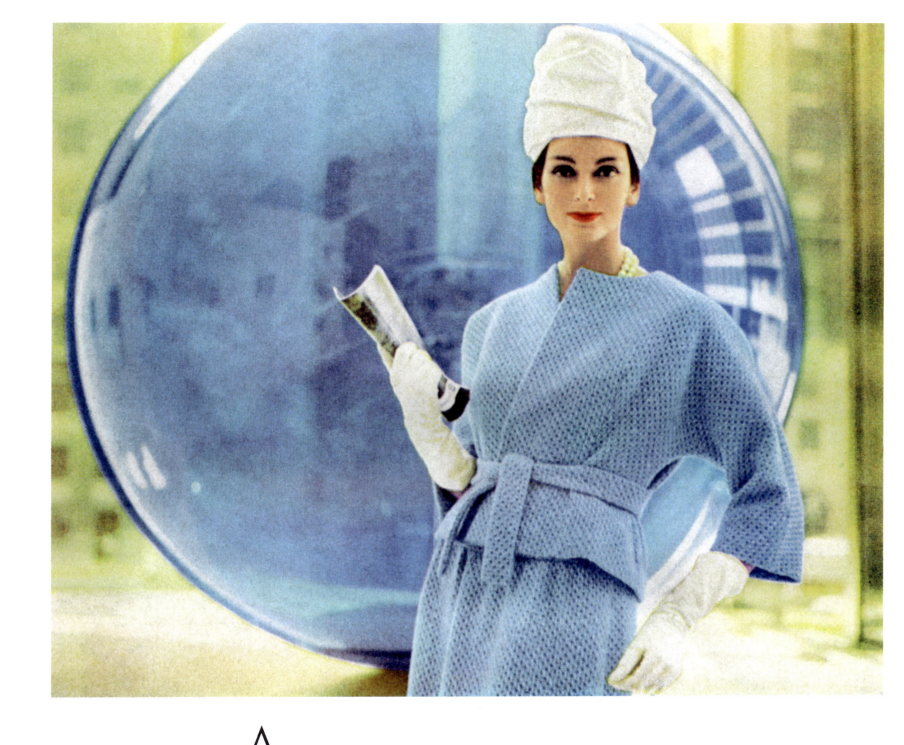

An enormous Uranium Atom exhibit by Will Burtin was opened
at the Union Carbide Building, 270 Park Avenue, in 1961, and for a shoot in February 1962 Gleb found this stunning display
of giant glass spheres irresistible. The sleekly modern Union Carbide Building was designed by Natalie de Blois, one of the
few women working in the upper echelons of the profession, who would be an activist for women in the workplace, and
who ironically was never given full recognition for her important work with the elite practice of Skidmore, Owings & Merrill.

FACING PAGE The mid-century modern of the 1950s might now have been taken to the next level, but fashion
still clung to its beloved Wear-Right gloves, here complementing a Halston organdy headdress, Richelieu copper
pearls, and early-morning-sun yellow wool chamois dress by Jerry Silverman. Pink Rubies lipstick by John
Robert Powers adds that finishing touch of simplicity and class, so quintessentially Carmen Dell'Orifice.
ABOVE Carmen wears a sky-blue Forstmann wool suit and white kid gloves by Dan Millstein,
topped with a froth of white silk meringue by the great Halston of Bergdorf Goodman.

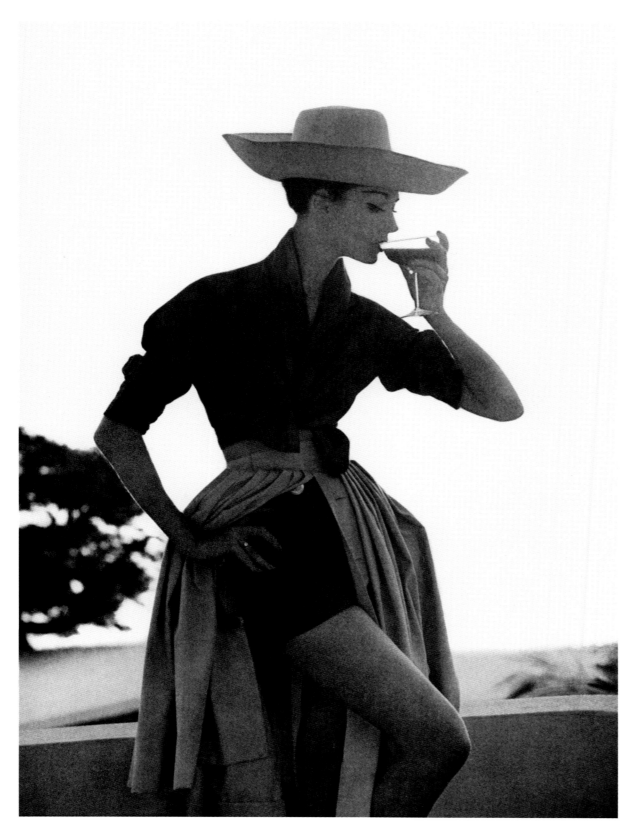

Simone is the epitome of chic in the stylish resort of Las Brisas Acapulco, in a charming combination of shorts and matching red paisley blouse with a gathered khaki wrap skirt, all by Tiktiner, with a straw sombrero by Emme, May 1959.

"THE EYE HAS TO TRAVEL"

Diana Vreeland, *Allure*, Doubleday & Co Inc., 1980.

An image shot on the estate of Gleb's friend and kindred spirit Boris Said. Bobby—as his friends called him—was an Olympic bobsled driver (in 1968 and 1972), a NASCAR racer, and an Emmy-winning documentary film maker (for the NBC feature *The Mystery of the Sphinx*). Born in New York, he was of Russian and Syrian heritage, spoke multiple languages, and was as captivating as Gleb. A larger-than-life character and inveterate risk-taker, he borrowed twenty-six hundred dollars to buy this 800-acre property in Pound Ridge, complete with a private zoo, and within a couple of years it was worth two million dollars. Many years after Gleb and Ruth had divorced, my mother was living on an estate Bobby had rented in Westport, Connecticut. It was huge and beautiful, with giant picture windows looking out over the bay. He decided he wanted a huge television but didn't have the money for it, so he went to the store where he asked the sales person to deliver it so he could try it out and see how well he liked it. After we had all enjoyed it for a month, he had them come to pick it back up. Gleb ended up racing cars with Bobby at Sebring Raceway. As Carmen Dell'Orefice said to me, "they broke the mold with Gleb and Ruth," and I could say the same for Bobby. They lived exciting lives, and they were willing to take chances.

FACING PAGE On a golden summer's day with a gentle breeze, perfect for sailing, Ruth wears a one-piece swimsuit in blue and violet tones, shirred with elastic, by Cole of California, January 1957.

"He was a rugged, handsome man, he was attractive. He was confident of what he wanted and what he was doing. A lot of photographers can be nervous and shy, but Gleb was not like that, Gleb was very confident. He had, like Norman Parkinson did, what I call 'the eye', a very distinctive photographer's eye with which they are looking at things and they are setting things up, as though they were already looking through the lens…. His fashion photographs have a great shape and they are very dramatic. They have an architectural structure and that's what makes them so powerful."

—Nena von Schlebrügge, model

FACING PAGE A fabulous composition of copper, bronze, and mustard tones featuring
a very limited edition 1957 Ford Thunderbird "Copper Penny" convertible, a 1956-57 Piper Apache
PA-23-150, a timeless Louis Vuitton case, and an unidentified model, April 1957.

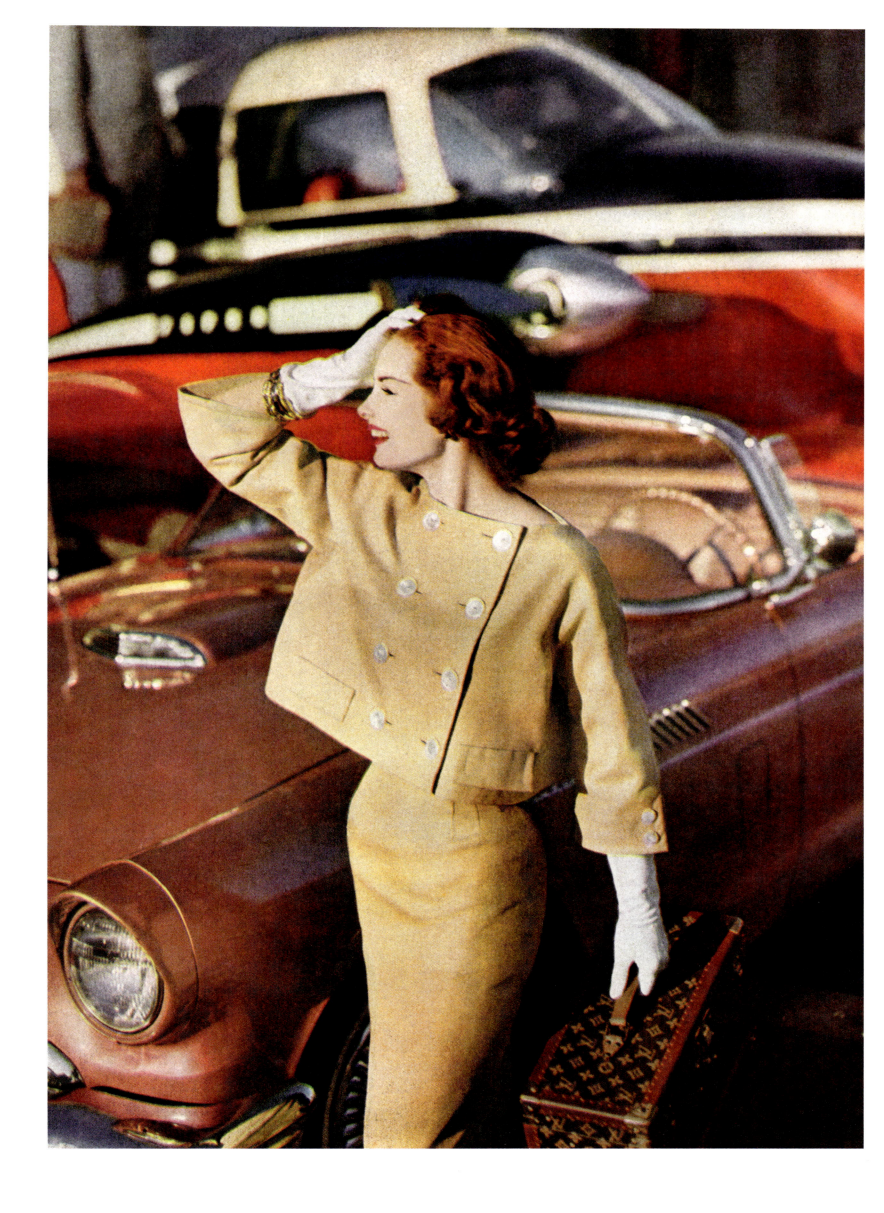

BELOW A glamorous landing at Chicago Municipal Airport in this beautiful Suzy Perette sheath dress in heavy white silk, Mr. John hat and Mademoiselle sandals. A powder-blue Chrysler Imperial Southampton with wraparound rear window waits to whisk you away. The last word in chic.

FACING PAGE In a hangar at Chicago Municipal Airport, a Dodge Custom Royal Lancer Hardtop in two shades of blue complements this Ben Barrack sheath dress in Moygashel linen with sporty white stripes, worn with Mademoiselle shoes and topped off with a Christian Dior hat, June 1957.

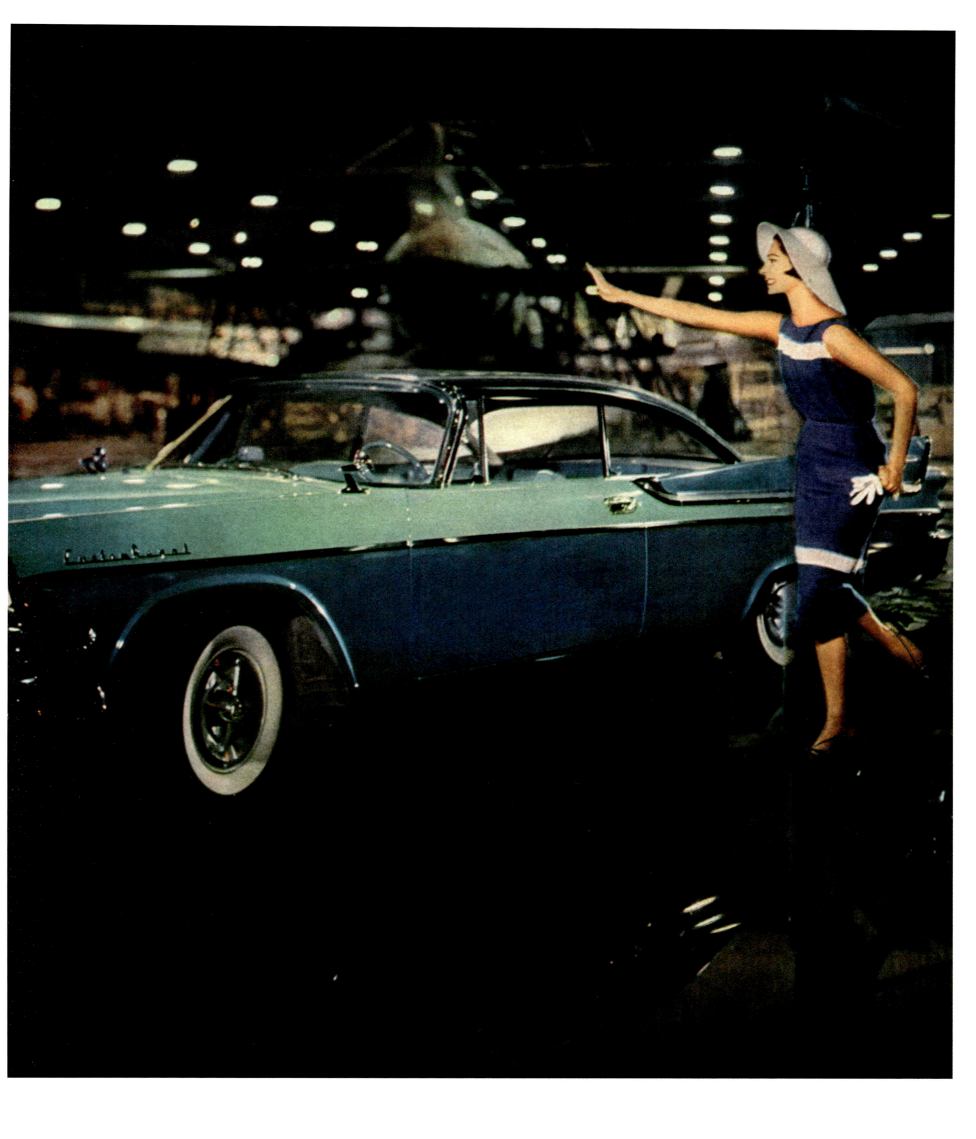

"Gleb was a man with elegant and refined taste. He could choose a background, pick a model, or suggest an accessory—always arriving at the perfect solution. His taste in everyday life was also very special—whether soaring in his glider, flying in his plane, or living a beautiful life in Pound Ridge—his overall outlook on life was one of discerning artistic vision."

—Barbara Slifka, Assistant Fashion Editor, *Harper's Bazaar*

FACING PAGE The very first Dior Juniors, designed for David Crystal and modeled by Iris, make their debut at the lovely Westport Playhouse in Connecticut. Meanwhile, a brand-new, much-hyped Ford Edsel two-door convertible waits at the stage door. A pretty blue Shetland wool Dior Junior dress with Middy jacket and matching fringed scarf. Pin by Mazer and gloves by Fownes, September 1957.

BELOW Wearing a cute two-piece Catalina swimsuit, in a setting that could hardly be more romantic or beautiful, Ruth gives Gleb a wink.

FACING PAGE Ruth in the wetlands again, wearing a Rose Marie Reid swimsuit, December 1957. The composition of the photo and the reeds in the foreground have all the delicacy and precision of an Andrew Wyeth painting.

BELOW As the sea laps gently against the sea wall, Ruth is given a lesson in mending fishing nets, looking cool and comfortable in a violet two-piece knitted suit by Mirsa.

FACING PAGE Seashore romance in an enchanting Sybil Connolly shamrock-green crushed linen skirt with a snowy crocheted lace top, silhouetted against the ancient buttresses of the Castello sul Mare, built in 1551 at Rapallo, near Portofino in Italy, June 1958.

FACING PAGE Gnarled ropes, a boat painted in flamboyant primary colors, a scarlet-framed porthole and a cigar-smoking fisherman make an eye-catchingly surreal setting for Carmen in a red-wine wool zibeline double-breasted coat with huge pockets by Lilli Ann and fez by Irene of New York.

ABOVE The staunch values of the American Collections are exemplified by this Frank Gallant deep-yoked coat lit by the setting sun over the Hudson River, not forgetting the charming hat by Lilly Daché, September 1958.

MELVIN SOKOLSKY
PHOTOGRAPHER

Gleb Derujinsky was a photographer, explorer, and adventurer, who traveled the world in pursuit of the natural wonders and beauty the planet has to offer. He piloted his own plane and traveled to exotic places with models and editors, who were many times terrified by the out-of-the-way destinations that attracted him. Gleb posed his models in a beautiful gestural harmony that enriched the locations he chose. It could be said without exaggeration that the images always transcended the fashions. One of his favorite models was Ruth Neumann, with her graceful giraffe-like neck, adorned in jewels, and draped in designer clothes, whether posing at an extraordinary rock formation or the Eiffel Tower. The model in the fashion image was at once transformed into a most beautiful creature only seen in the wild.

FACING PAGE Arguably one of the greatest beach shots ever published, the sea-blue swimsuit, white surf, and fringe of green palm trees making a riveting image against the coal-black volcanic sands of Punalu'u Beach, Hawaii. Carmen wears a swimsuit by Cole of California, January 1959.

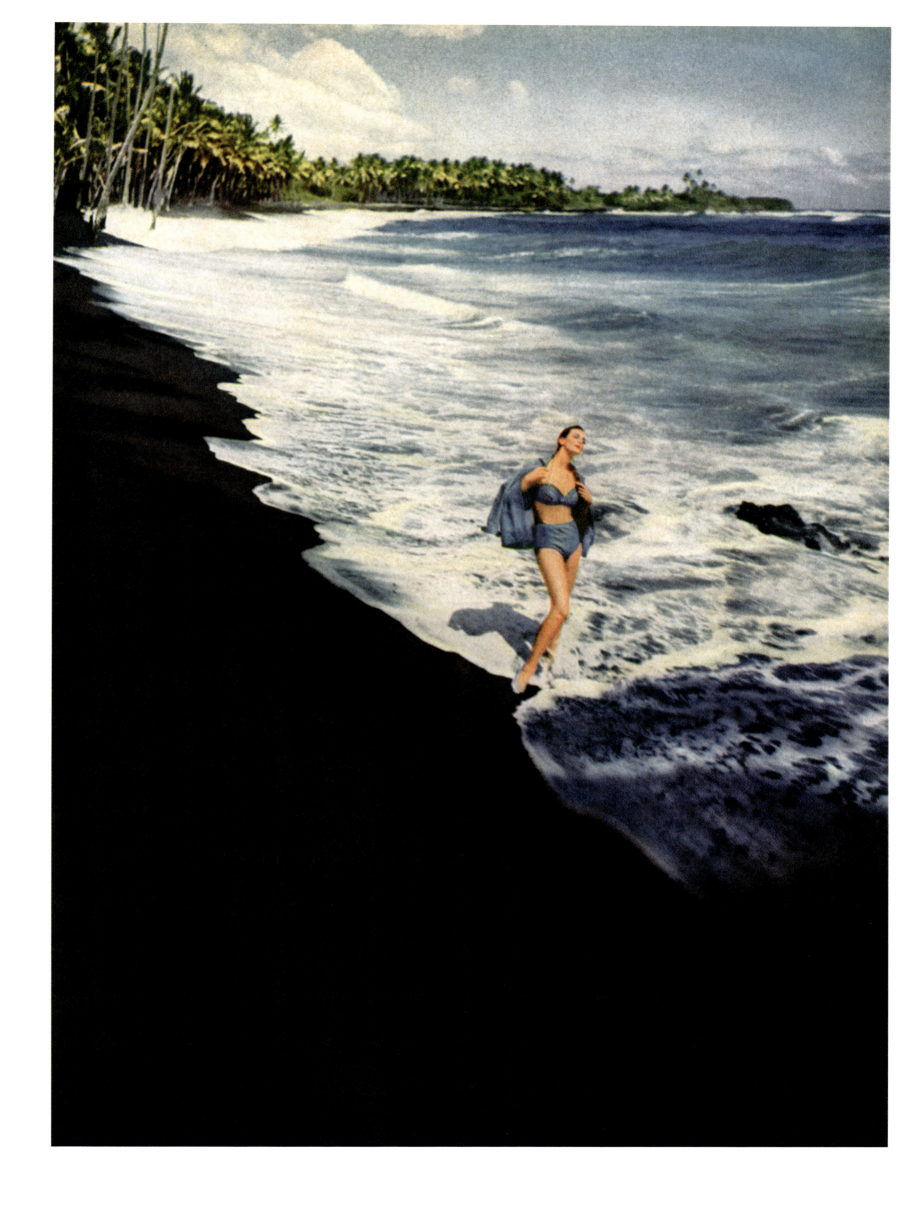

BELOW Making a big splash in a Sportwhirl white cotton tunic against the black rocks and sand of Punalu'u Beach, on the Big Island of Hawaii, May 1959.

FACING PAGE With its golden sands and lush mountain backdrop, Tunnels Beach, at Haena Point on Kauai's northern shore, makes a spectacular setting for a swimwear shoot. This idyllic beach has a dual personality: in summer it is a serene haven for snorkeling, while in winter its huge waves make it a surfers' paradise. Whichever your preference may be, be sure to pick up an authentic Hawaiian swimsuit and matching "Happi" tunic by the Kamehameha Garment Company, established in the mid-1930s, January 1959.

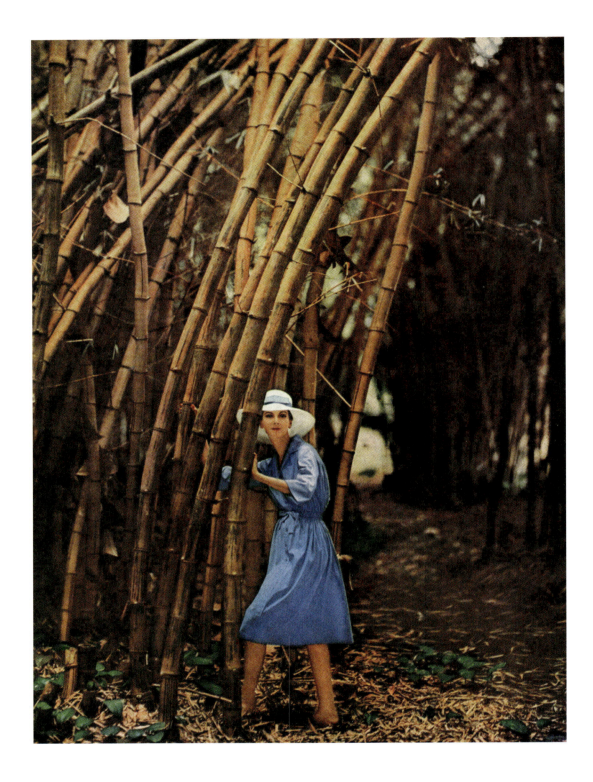

ABOVE The cover shot that wasn't: tropical breezes in the dense Bamboo Forest
(Na'ili'ili Haele) in Maui call for a cool cotton dress by David Crystal, January 1959.

FACING PAGE An immaculate Herbert Sondheim dress in Moygashel Irish linen,
with a stunning leghorn hat by Lilly Daché, May 1959.

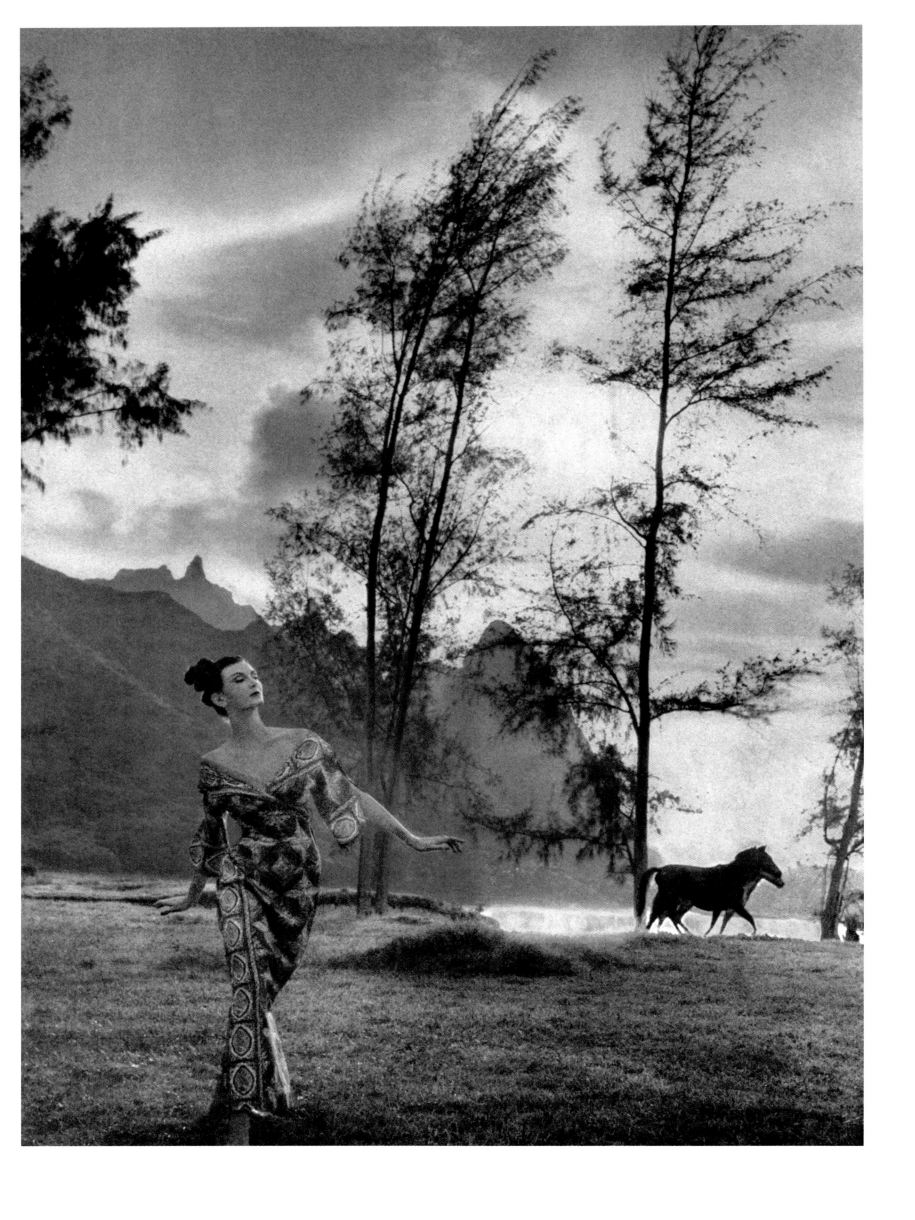

ooking west towards Makana Peak (Bali Hai) near
Hanalei Bay on Kauai: an early morning hike, Derujinsky-style, with "wild" horses and rainbow eucalyptus blowing
in the gentle breeze. Local color comes in the form of "Nani" print Cohama cotton (FACING PAGE).

BELOW The atmospheric scenery of Lake Pátzcuaro in the state of Michoacán in the Mesa Central region of Mexico,
a large volcanic lake on which the Purepecha people have fished with beautiful butterfly nets since the days of the rival
Aztec empire. Cabana beach poncho in Ariel sharkskin by Folker, tall straw hat by Emme, May 1959.

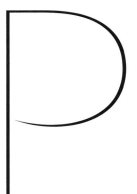 oza Alberca Hotel El Mirador in Mexico has changed
a little since 1959, and more people have discovered this unique location. But Gleb wanted to record this lovely spot
for posterity, and, happily, the steps cut into the rock and the natural pool nearby are very largely unchanged.

ABOVE Standing in a hand-carved canoe that could well be many centuries old, Simone sports a dazzling white beach
jacket with white shorts designed by Tina Leser, with an Echo black-and-white scarf. FACING PAGE The retro 1900-style maillot
is by Cole of California, while the silk and organdy beach coat and full-skirted bathing "dress" are by Catalina, May 1959.

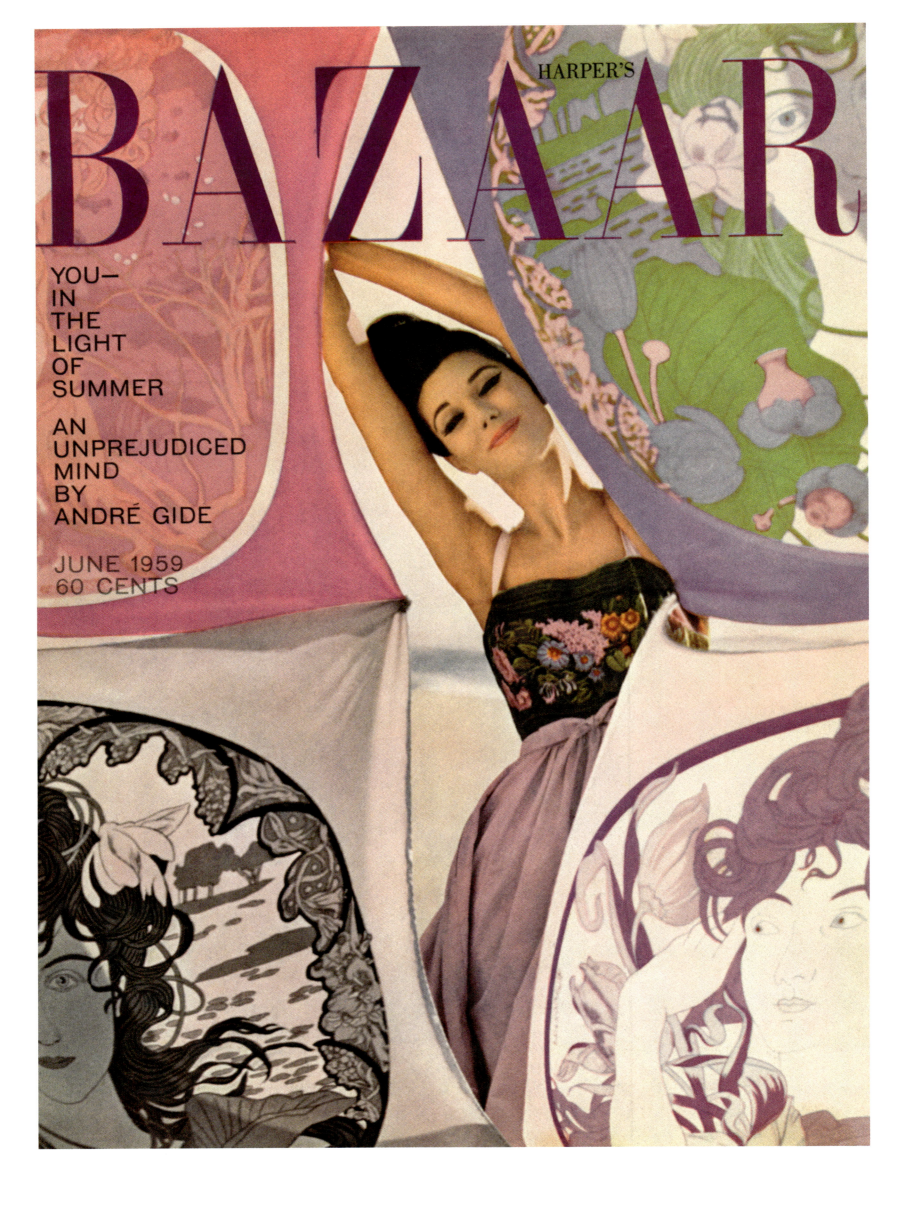

HARPER'S

BAZAAR

YOU—
IN
THE
LIGHT
OF
SUMMER

AN
UNPREJUDICED
MIND
BY
ANDRÉ GIDE

JUNE 1959
60 CENTS

These Falconetto silk scarves on Puerto Marquez Beach make a dreamily beautiful
cover shot featuring a Tiktiner cotton dress, June 1959.

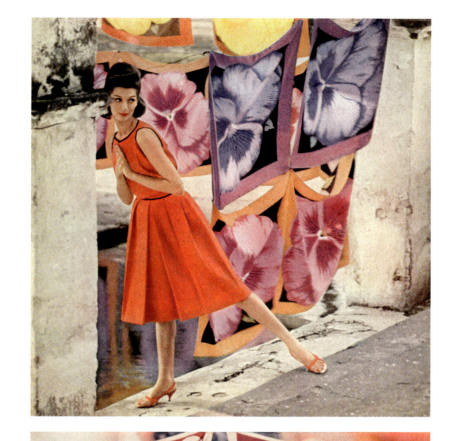

The only clue to the identity of this location—as lovely as it is mysterious—lies in Gleb's pictures from his May shoot in Mexico. The Falconetto silk scarves that billow gently in the soft breezes under romantic ruined arches.

FROM TOP TO BOTTOM This stylish dress by B.H. Wragge in Moygashel Irish linen captures the carefree feeling that floats on the warm breeze. Sandals by Evins. Sichel Belgian linen dress by Donald Brooks for Townley, with Evins sandals and lipstick by Charles of the Ritz. Crumbling stonework and Falconetto pansies make an evocative backdrop for a Sloan dress with inverted pleats in Moygashel linen, with red sandals by Mademoiselle, June 1959.

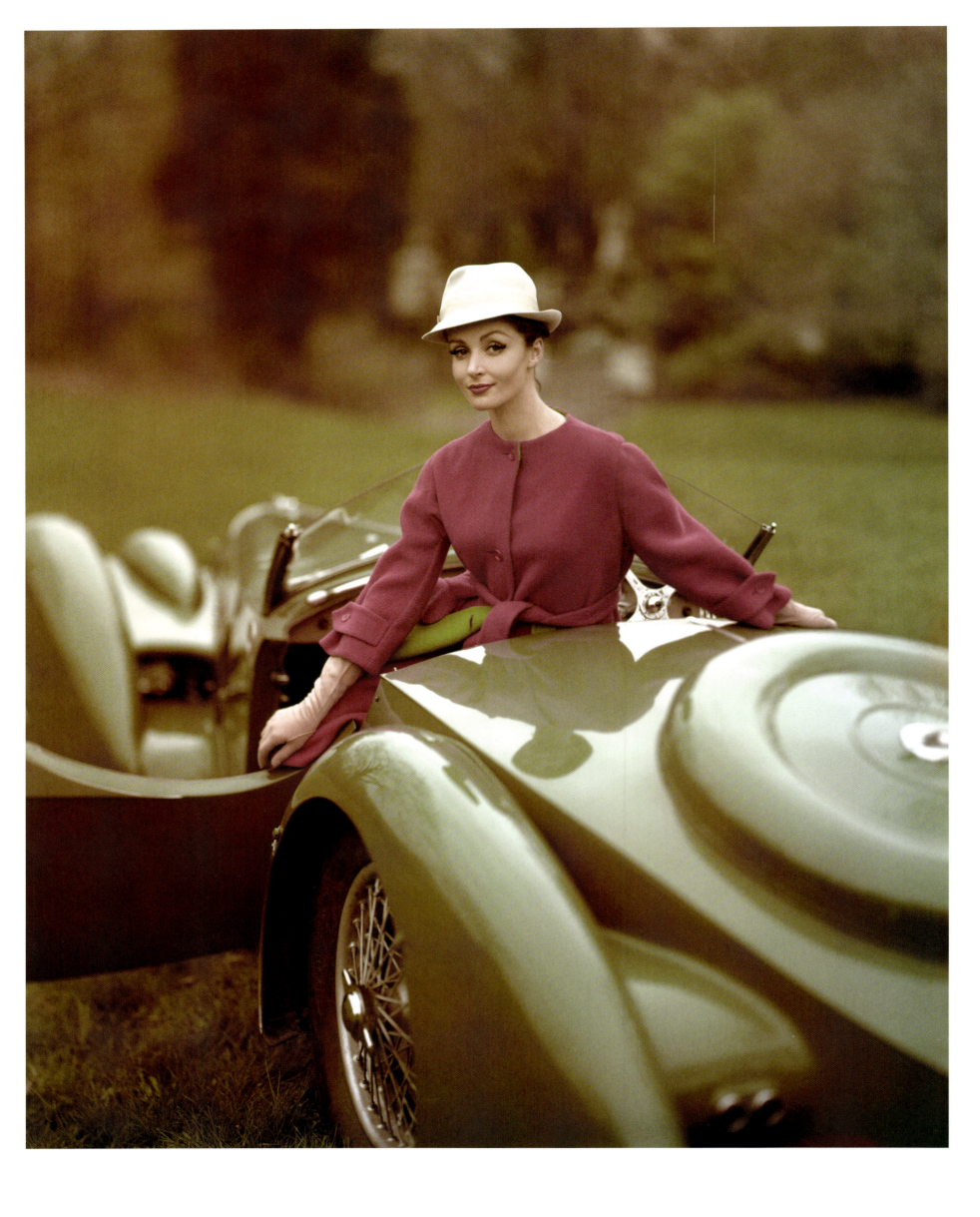

FACING PAGE Iris in Erwin Goldschmidt's 1957 SC Bugatti, wearing a reversible double-faced wool fleece trench coat in brilliant red and green Casentino wool by Originala, Crescendo gloves, and Spiced Peach lipstick by Antoine de Paris. This shoot was only made possible because Gleb had met and become friends with Erwin, a successful racecar driver, when they both raced for Ferrari America in around 1954.

BELOW Samuel Roberts blue suede tunic and slim pants (left) and Braemar red Casentino cashmere sweater paired with a Tutor Square tweed cloche skirt to match (right). Shoes by Evins.
The Lafayette Escadrille Nieuport 28 vintage biplane was from the Palen collection in Rhinebeck New York, established by James Henry Cole Palen Jr. Gleb himself flew sailplanes with his lifelong friend George Moffat, who co-starred with him in Robert Drew's influential documentary *Sunship Game*.

ABOVE Peppermint pink elasticized bouclé swimsuit by Jantzen, softly framed by the fronds of a weeping willow—and by the tresses of the model's Joseph Fleischer hairpiece, in anticipation of the dawn of the 1960s.

FACING PAGE Brown swimsuit by Rose Marie Reid, the hugely successful Canadian-born swimwear designer who believed that women should feel as glamorous in a swimsuit as they would in an evening gown, December 1959.

MY MAGICAL SPAIN

In 1960, *Harper's Bazaar* decided to devote a special edition to Spain. Diana Vreeland called me in to ask me to model for it. The photographer was to be the talented Gleb Derujinsky.

So the whole team set off from New York en route for Spain—Marbella, Andalusia, Grenada, and to finish off, Seville! Gleb had chosen the locations with care: the beaches of Marbella, the Alhambra in Grenada and its magnificent mosaics, Seville and Andalusia, with its wonderful people and entrancing atmosphere. Everywhere we went we were dazzled by the architecture, the colors, the music, the gypsy accents, and the moving songs the people sang to us. Through his photographs, Gleb showed us his talent once again, enchanting us with images that will be imprinted on my memory forever.

Our trip was dazzling, we all developed a strong affection for each other, like a group of young friends traveling the world together and discovering marvelous places. Every working day was marked by laughter and happiness, as well as by strong discipline and great professionalism. We all did all we could to make sure we delivered the photographs that *Harper's Bazaar* was expecting to Diana Vreeland.

Our fantastic journey lasted two weeks—two weeks during which we shared the experiences of a lifetime. At the end, we were all a little sad to part from each other. Every member of the team was an essential piece of the puzzle put together by Gleb, who was like an orchestra conductor, making each of us feel that the success of the photographs depended on our communication as a group.

I worked with Gleb a few more times after that. We lived at a hectic pace at that time, we were citizens of the world, and we were part of the little world of fashion at a unique and privileged time, a golden age. There were not many of us, compared with the fashion world today; we all knew each other, and we all stuck to the rules. A sort of diplomacy and savoir-vivre floated in the air of this sophisticated world, and every photographer, every art director, every model, every editor, and every assistant, however young, felt that they were an integral part of it. Looking back on it all fifty-six years later, I wonder at our innocence: we had no idea that together we were creating the fashions of an era that would be so sorely missed, imitated, but never equaled.

As time went by, Gleb and I lost touch with each other, and I withdrew from the fashion world to look after my family and bring up my daughters. I went back to South America to live among nature. Many years later I renewed my links with fashion and had the privilege of meeting my dear friend Andrea Derujinsky, who ensures that the genius and memory of her father Gleb live on today.

Deep in my heart, Spain will always be associated with Gleb's smile, with the sun, with the bewitching music, with the laughter and perfume of youth.

KOUKA DENIS, Dior model

FACING PAGE Kouka Denis looks so simply chic in a navy-blue over-sized blouse and white Helanca stretch nylon pants by Pius Wieler, against the brilliant colors and intricate paterns of the ceramic tiles on the bridge, in Plaza de España in Maria Luisa Park, Seville, Spain. January 1961.

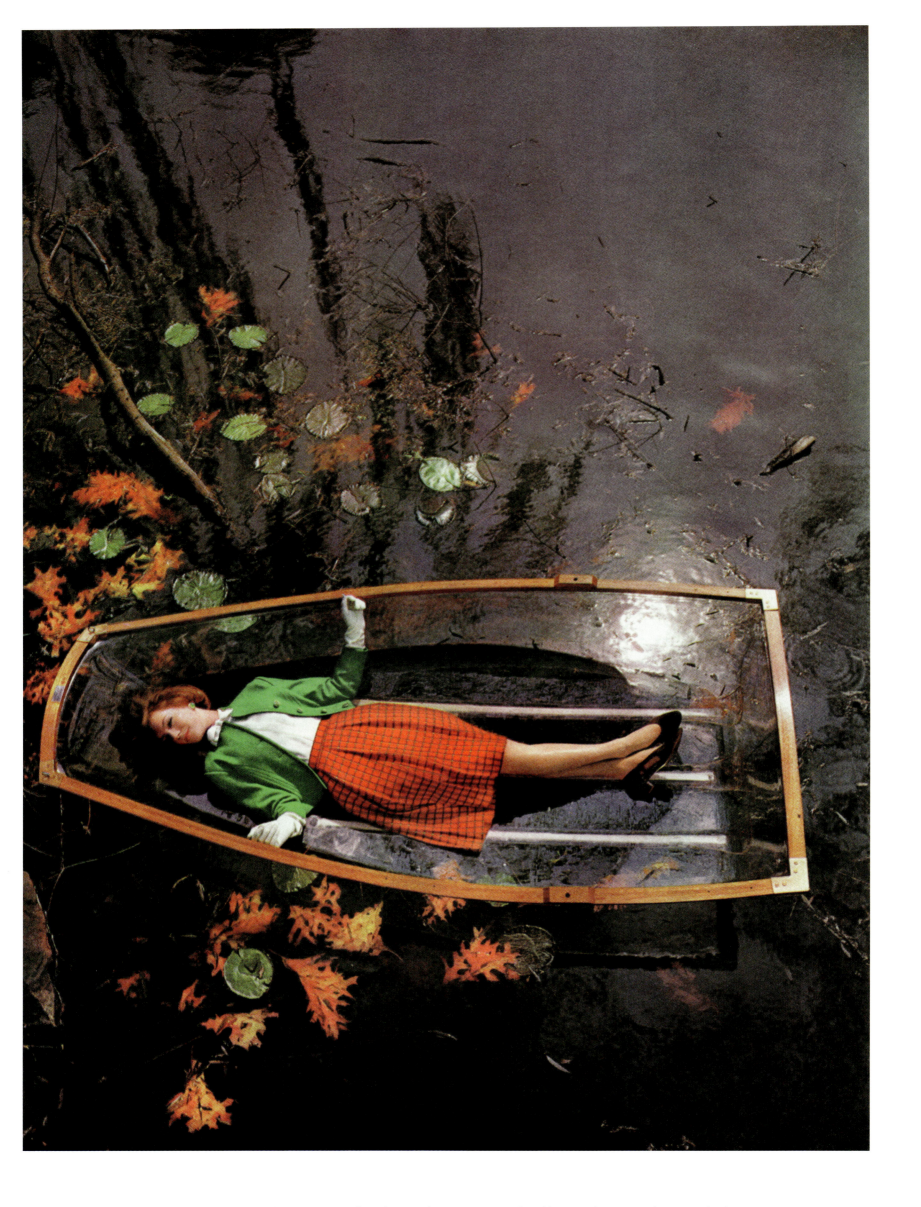

Grass-green wool cardigan jacket worn over a white blouse with pussycat bow, matched
with a green-and-red checkered wool skirt, all by Robert Sloan. Bur-Mil Cameo stockings,
Capezio shoes, Miriam Haskell earrings, Wear Right gloves, August 1961.

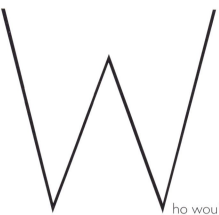

ho wouldn't love a "glass" boat? In this sequence of shots, Gleb captured all the magic of floating serenely among water lilies and fallen leaves, while the rays of the setting sun reflect mauves and sage greens to complement the fashions for fall 1961. The intriguing transparent dinghy was built by the Sudbury Boat Company in Ontario, Canada.

BELOW, LEFT A superbly chic three-part ensemble, with an opulent opossum-collared coat over a sleeveless blouse and slightly flared matching skirt, by N.S. Juniors in Strong/Hewat wool and—of all things—reindeer hair. Narrow boots by Capezio add the perfect finishing touch to this all-American early 60s' look., BELOW, RIGHT Grass-green suede dress with brass nugget buttons by Leathermode worn with hat and Symphony scarf by John Frederics, Realsilk stockings, Millerkins shoes, Kislav gloves, and High Key Coral Bright Blaze lipstick by John Robert Powers, August 1961.

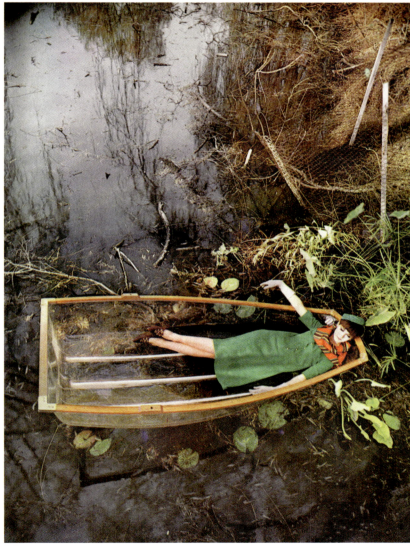

BARBARA SLIFKA REMEMBERS...

One fateful day, Gleb Derujinsky happened upon pictures in *National Geographic* of colossal stone figures seated atop the Turkish mountain of Nemrod Dagh overlooking Mesopotamia and the Euphrates Valley. Four weeks later, a whole little *Harper's Bazaar* contingent was standing, albeit somewhat dazed, on that very same spot—an adventure into another century and another civilization happened as quickly as that. Going up the mountain, there were six of us: Gleb, Ruth, Gleb's assistant Minoru Ooka, model Nena von Schlebrügge, a young male translator, and myself. Ruth and Gleb had a huge fight at the foot of the mountain, and she said she would not go up with us. The translator told her, "If you stay in the village, you'll be dead in the morning." Your mom decided to come along. We went up the mountain on donkeys as it would have been silly to use camels. Halfway up, there was a tiny house with a postcard of the Statue of Liberty on the wall. The owners gave us delicious yogurt. We slept in tents that were there. We took with us a live chicken, which we [slaughtered and] cooked, and a bottle of Scotch, which we drank. We got up at dawn or a little before, took the pictures, and left.

Here, Ruth holding hands with a local boy, with Nena and camels, on a beach outside Istanbul. Ruth wears a navy blue maillot by Elisabeth Stewart, Sultana sunglasses, and Knize scarf; Nena looks a camel in the eye in a white Peter Pan swimsuit with navy blue dots of a polished cotton, January 1962.

The magnificent head of Antiochus, King of Commagene. Over the centuries these commanding statues have suffered not only from iconoclasm (in a telltale sign, most of the faces have lost their noses) but also from the unforgiving climate of this remote mountainous spot, which lies under snow for six months of the year and is baked by the sun in the summer. Here, Nena basks in the heat of the sun in a cocoa brown maillot by Catalina and crisp white organdy coif by Halston, January 1962.

NENA
VON SCHLEBRÜGGE
REMEMBERS...

One spring day I was asked for a "go see" to *Harper's Bazaar* for a possible trip to Turkey. Apparently Gleb Derujinsky, a famous fashion photographer, had chosen me to be the model for the assignment, along with his wife Ruth, also a model. When I arrived I was ushered into Diana Vreeland's inner sanctum, where the editor Barbara Slifka and a few others were waiting. I was asked to try on some outfit, so that Diana could see how it/I all looked…. I'd never met her before, although I had been working for *Vogue* and other high fashion magazines since coming to NYC just a few years earlier.

Miss Vreeland narrowed her eyes whilst looking at me, then stepped forward and, on the pretext of adjusting the dress, quite deliberately pinched my left breast! No one else noticed. It did hurt, but I decided to pretend it hadn't happened and kept a straight face. I later thought it was some sort of test, to see what kind of reaction she could elicit…. Who knows? It was odd, but then the fashion world in those days was full of eccentric and artistic types, which I loved and liked.

Some time later we all flew to Ankara, where we were met by a local guide, who would act as interpreter and help Gleb to get to where he wanted to go. Gleb had done his research and had chosen several famous archeological sites for backgrounds. The most exotic one was at the top of Nimrod Mountain, which consisted of several Easter Island-size sculptured heads of kings and gods, where we ended up doing the cover and several more shots.

I should mention that Ruth arrived with a terrible cold, that I then also shared, so that by the time we got to Nimrod, I had to struggle with looking good, despite the way I felt. Luckily, she came well equipped with a bottle of syrup with codeine, which she kindly shared with me, and that did help make a difference! Ruth was a sweetheart and we got along famously. Anyhow, after some days we arrived to discover that there was no road up to the top of the mountain!

So our guide arranged to load all the *Vogue* boxes and luggage onto rented donkeys and we set out on foot, climbing the rest of the way. I wish Gleb had taken a photo of that scene, with the loaded donkeys and us huffing and puffing as we scrambled our way up the steep slope. Once there, it was quite sparse and we slept on cots in tents, and shared a simple dinner at an outdoors fire with the lady archeologist in charge. I remember the stars at night were sparkling and magnificent. The site was still being excavated then and is now one of Turkey's most important ancient monuments to visit. Traveling and working with Gleb was a wonderful experience, as he had such a sense of adventure and a great eye for great outdoor scenery as backdrops for his fashion shots. I also liked traveling the world and visiting remote places. When I started my modeling career, a lot of it was doing outdoor shots with Norman Parkinson, who also had this eye for fashion in the setting of nature. Since I always have loved nature and living in the country, I remember this trip as one of my favorite ones during those days, long ago.

"Gleb's work is ethereal, timeless, other-worldly, and a joy to look at and enjoy over and over again."

—Patty Sicular, Trump Model Management

FACING PAGE Monument Valley, home to the Navajo Indian Nation and known in Navajo as Tsé Bii' Ndzisgaii, covers over 90,000 acres on the borders of Utah and Arizona and is one of the most breathtaking places on Earth. This was one of Gleb's last fashion shoots, but he would return to this compelling landscape on many camping trips, and take endless photos—insisting that we kids shouldn't move, or even breathe for that matter, until he got the shot.

ABOVE Monument Valley, Arizona-Utah border, one of a set of dramatic shots that may never have been published, late 1960s.

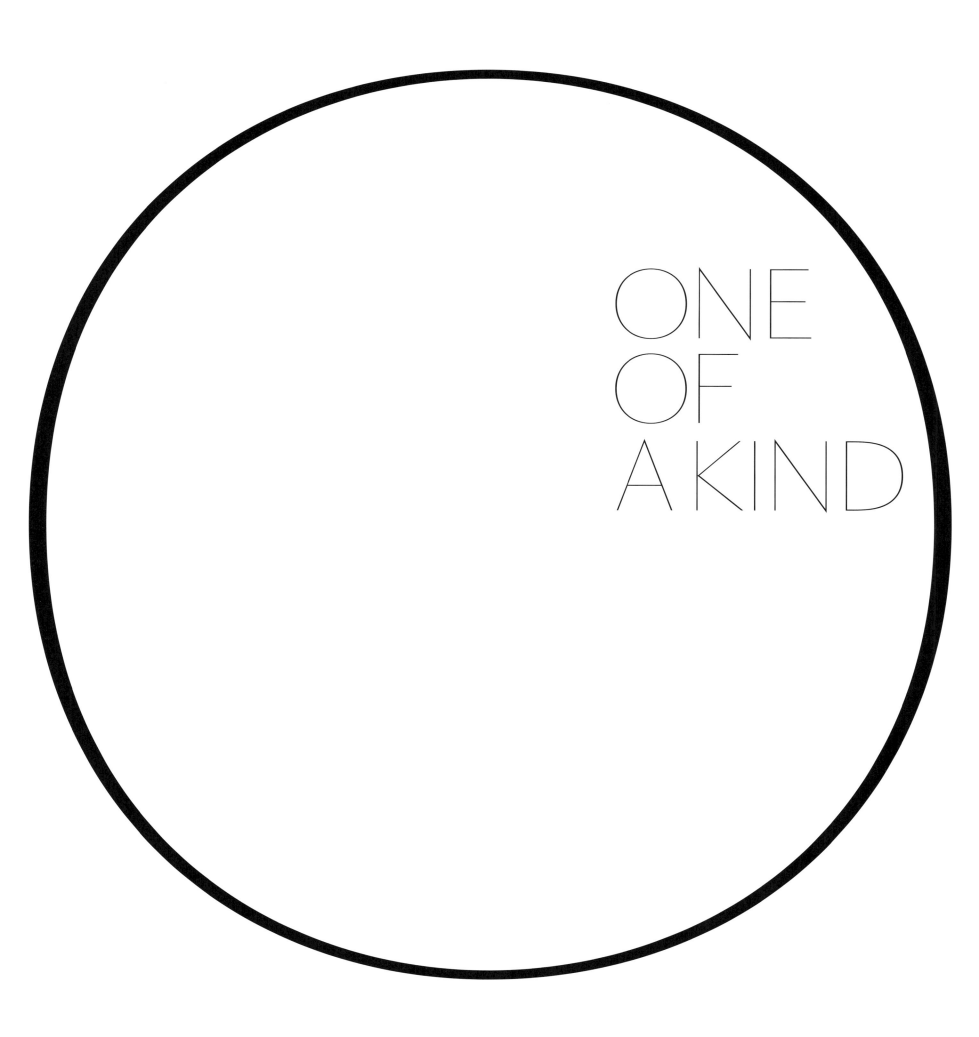

ONE
OF
A KIND

MY FRIEND GLEB

I first met Gleb Derujinsky at the US National Soaring Championships in Adrian, Michigan in 1965 when I was sixteen. It was my first time as a crew member, and my pilot, Dean Svec, went on to win the championship. Gleb, who was flying the same glider as Dean, seemed quite unusual to me, a hick from the Midwest, but was very friendly and entertaining and, oddly, paid attention to what I had to say.

The 1966 Nationals were at Reno, Nevada, and I remember cleaning Dean's Sisu several days before the championship started when Gleb and co. made their grand entrance tearing across the tarmac in a filthy Oldsmobile Toronado (the first front wheel drive car). His wife, Ruth and, I think, his son Peter were crewing for him. This was the first time I met Ruth.

Dean informed me that he would not be attending the 1967 nationals, and I immediately panicked as I didn't want to miss out on the excitement. I somehow got Gleb's phone number in New York and decided to call him. He surprisingly said that he would like me to come on board as a crew member.

The 1967 Nationals were in Marfa, Texas, and Ruth was to drive to Ohio, pick me up, and head for Texas where Gleb would meet us as he had work to finish in New York. Ruth was a blast to travel with and she told me many stories about Gleb, and after two days in the car I felt that I already knew him quite well.

I remember one day in particular when Gleb landed out on the course during a distance within a prescribed area task, and we got the message that he had landed on a ranch in a very remote area of Texas. It took us until nearly sundown to get there and, when we did, there was Gleb, sitting on the veranda of the ranch house wearing a wildly patterned and multi-colored Gucci shirt with his long silver hair, chatting and laughing with the seventy-year-old rancher who was dressed in Carharts and sporting a buzz cut, like they had been best friends for years! Gleb, if he chose to, had this knack for being able to blend in with almost anyone that he came in contact with and make them feel like he was "one of their own."

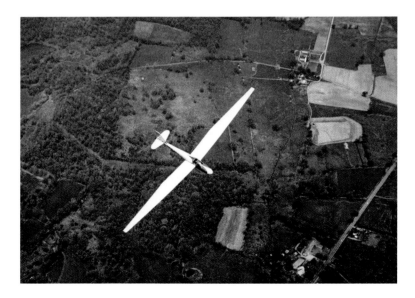

PAGE 216 AND FACING PAGE Gleb in his glider after a flight, mid to late 1950s. LEFT Gliding over farm fields. Glider pilots know they must always keep track of the land below, as they never know when the lift will give out and they will have to land. Gleb had many wonderful stories to tell of these landings. Dressed n GQ style and as down to earth as anyone, he made friends with all the farmers.

Gleb always had me fly to New York several days early to prepare the glider for the upcoming championship and I would stay in Gleb's apartment on 76th St. between Madison and 5th Ave. My first lengthy stay in the Big Apple was in 1968. I quickly learned how to navigate my way around the city by car as Gleb had me running everywhere to not only get the things we needed for the trip but to pick up items that he needed for the studio. After the championship, Gleb hired me as a gopher (a person who did anything that no one else wanted to do) on the set at the studio. It was a wonderful experience and Gleb would always take me along to dinners with clients and his friends and include me in weekend social activities wherever they were. He started my pocket watch collection (he had a magnificent collection) and exposed me to excellent restaurants that prompted my love for cooking.

I finished crewing for Gleb in 1970, but we remained close. I would get together with him regularly, especially after he and Wally moved to Durango where I would stop and spend a day or two with him while on motorcycle trips out West. He would spend a lot of time at the piano with my wife Lois discussing the complexities of Chopin.

Gleb was one of the most influential people in my life and broadened my exposure to so many different and wonderful experiences and aspects of life and for that he will forever hold a very special place in my heart.

JOHN "BOO" BUCHANAN, Crew Chief, Charlie Item

Poolside in Acapulco, at the beach house of the distinguished Cuban-born fashion designer Luis Estévez, the Swedish model Lisa Fonssagrives—often regarded as the first supermodel—is the incarnation of effortless elegance in an orange empire shift and flowered organdy jacket in Gordon silks.

ACKNOWLEDGMENTS

I want to express my deepest gratitude to the many who have helped me along the way over the past years.
And I must say in no order as for me each is #1 in my book.
Barbara Slifka, Cassie Ann Ross, Carmen Dell'Orefice, Paccione, Eileen Ford and family, Carol Green, Dolores Hawkins, Patty Sicular, Glenda Bailey, Aaron Lyle Leth, Julia Pysmenna, and the many staffers of *Harper's Bazaar*, Timothy Greenfield Saunders, Melvin Sokolsky, Susan Camp, Iris Bianchi, Bruce Clerke, Lisa Foster, Jessica Hastings, Mark Vieira, John Buchanan, Howie Kicklighter, Karin Kato, Bruni Padilla, Harry MacGrotty, Minoru Ooka, Dian Ooka, Linda Morand, Fathom Gallery, Michael Gross, Robert Drew, Derek and Jill Drew, George Moffat and the many pilots who loved Gleb, M. Gallagher Brown Gallery, Suzanne Tise-Isoré, Bernard Lagacé, Inès Ferrand, Barbara Mellor, and Marie Boué.
To my mother Ruth Neumann-Derujinsky.
To my Dad and to my stepmother Wally for leaving the work to me, and my wonderful, patient children Madeline and Andres whom this legacy is for.
Thank you all.

ANDREA DERUJINSKY